PRESENTS

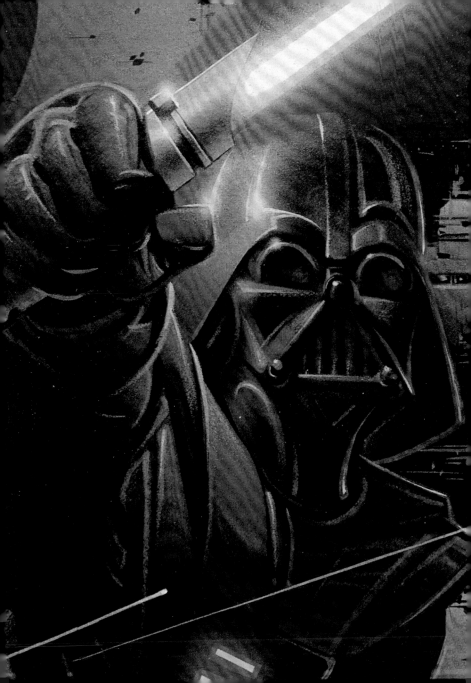

STAR WARS™ GALAXY

THE ORIGINAL TOPPS TRADING CARD SERIES

INTRODUCTION AND COMMENTARY BY GARY GERANI

AFTERWORD BY DREW STRUZAN

TO IRA FRIEDMAN OF TOPPS,
MY CO-CONSPIRATOR FOR ALL THINGS *STAR WARS*

ACKNOWLEDGMENTS: Special thanks to Len Brown and Charles Lippincott, who lived the adventure with me. Thanks also to Ira Friedman at Topps; J. W. Rinzler, Samantha Holland, and Carol Roeder at Lucasfilm; Harris Toser and Roxanne Toser at *Non-Sport Update*; and Marty Grosser at *Previews*. At Abrams, thanks to Nicole Sclama, Orlando Dos Reis, and Charles Kochman (editorial), Pamela Notarantonio (design), Jen Graham and Leily Kleinbard (managing editorial), and Alison Gervais (production). And thanks to Jonathan Beckerman (photography).

Images courtesy of Robert V. Conte, with assistance from Dave Streicher, from the *Rebuilding Robert* Collection

Additional images on pages 19 and 213–15 courtesy of Harris Toser and Roxanne Toser at *Non-Sport Update*

Image on page 6 courtesy of Bill DeFranzo

Image on page 18 (bottom) courtesy of Gary Gerani

Photography by Johnathan Beckerman: back cover, endpapers, and pages 9, 11–12, 14, 16, 20, 92, 164, and 224

Editors: Orlando Dos Reis and Nicole Sclama
Project Manager: Charles Kochman
Designer: Pamela Notarantonio
Managing Editors: Jen Graham and Leily Kleinbard
Production Manager: Alison Gervais

Library of Congress Cataloging-in-Publication Data

Star Wars galaxy : the original Topps trading card series / introduction and commentary by Gary Gerani ; afterword by Drew Struzan.
 ISBN 978-1-4197-1913-4 (hardcover)
1. Star Wars films—Collectibles. 2. Trading cards.
 PN1995.9.S695 S78 2016
 DDC 741.6—dc23
2015028336

Printed and bound in China
10 9 8 7 6 5 4 3 2 1

Abrams ComicArts books are available at special discounts when purchased in quantity for premiums and promotions as well as fund-raising or educational use. Special editions can also be created to specification. For details, contact specialsales@abramsbooks.com or the address below.

ABRAMS
THE ART OF BOOKS SINCE 1949
115 West 18th Street
New York, NY 10011
www.abramsbooks.com

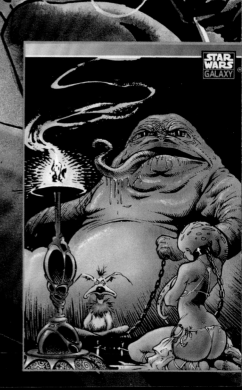

INTRODUCTION
TAKING OUR FIRST STEP INTO A LARGER WORLD...
BY GARY GERANI

Art, in the form of both imaginative conceptual design and promotion, has always been a key component of the *Star Wars* experience. Audacious alien creatures, futuristic vehicles, exotic planetary landscapes—all these and more needed to be created from scratch and brought to life convincingly for movie audiences. A collection of these fanciful renderings seemed fitting for a Topps trading card series, given the image-after-image format of collectible sets and the ongoing demand for fresh visual material. But launching such a project turned out to be more complicated than we editors at Topps headquarters expected, resulting in a whole new direction for *Star Wars* as a card franchise and for our ongoing creative relationship with Lucasfilm.

Let's travel back in time to the early 1990s. Specialty stores known as the "direct market," which carried comic books and related merchandise, were suddenly exploding. One of our card competitors snagged the Marvel license and was doing quite nicely with an art set

aimed specifically at this niche audience. Unfettered by mass-market commercial concerns, direct-market cards were created with fan sensibilities front and center . . . no funny captions underneath these super-hero portraits, thank you. Just great art printed on quality stock and no-nonsense statistics and factoids about the characters. A new age of specialty trading cards had clearly arrived, with the old rules and notions about commercial viability suddenly out the Thirty-Sixth Street window. This posed an interesting challenge for Topps, still the industry leader when it came to collectible, pocket-size Americana. True, the company didn't have a roster of super heroes to draw on for fan-tailored confections. But Topps was still partners with something just as good, maybe even better: the cosmos according to George Lucas, which had changed the world of pop culture a decade and a half earlier. What better way to make a splash in this new collecting environment than with the property that epitomized sci-fi/fantasy at its most entertaining?

Now based in California (as "Topps West"), I was awakened one morning by a phone call from Ira Friedman, head of our New Product Development department in Brooklyn.

As Ira remembers, "It was the fifteenth anniversary of *Star Wars*, and both Topps and Lucasfilm wanted to do something different, some special kind of card set worthy of the saga."

It had been more than five years since I wrote and edited the last product based on Lucas's property: two series of *Return of the Jedi* trading cards and stickers linked to the release of the film. That series went the traditional Topps route, with photos from the movie arranged in story-line order, captioned, and supported by text on the backs. This time, Ira and I agreed, our approach would be far more adventurous. All three films were to be celebrated, along with the various TV movies and specials, cartoon series, books, comics, and other tie-ins. Indeed, the entire universe of *Star Wars* would be colorfully explored, but this time with an emphasis on art, not photos, tapping into the successful formula established by Marvel's illustrated card series.

What a prospect . . . I envisioned breathtaking fantasy paintings inspired by Lucas's trilogy, rendered by the field's top illustrators. Reflecting this "if we build it, they will come" enthusiasm, my initial two-page proposal boasted the considerable talents of people such as Thomas Blackshear, Boris Vallejo, and John Berkey.

"Any ideas for a title?" Ira asked.

I had one right up my sleeve. Although *The New Art of Star Wars* was a handy working moniker during this early stage

of preparation, all parties involved wanted something a little punchier. So I wrote four titles on a piece of paper, put an asterisk next to one of them, and faxed this list (remember faxes?) to Brooklyn headquarters. Without thinking twice, Ira happily approved my preferred choice, which now seems obvious in retrospect. If Marvel could dazzle fans with its multifaceted "Universe," why couldn't a certain "g" word be employed to convey Mr. Lucas's equally complex and enduring cosmos? Thus *Star Wars Galaxy* was officially born, tying into the film's famed opening statement and reinforcing the idea of a very dense, all-encompassing overview of our cherished subject. This title would be reused for Topps's eventual fan magazine, edited by Bob Woods, while developing into a handy catchphrase for the trilogy in general.

"That original art proposal was intriguing," recalls Ira. "But since we were trying to get this product out by 1992, to tie in with the fifteenth anniversary of *Star Wars*, we decided to go with something a little more practical."

At first, anyway. Once again photos and preexisting material from Lucasfilm would form the basis of our product, but this time the editorial approach would be much more sophisticated. Subsets such as "Weapons," "Vehicles," and "Planets," to name a few, would offer a good deal more than the old scene-by-scene story-line

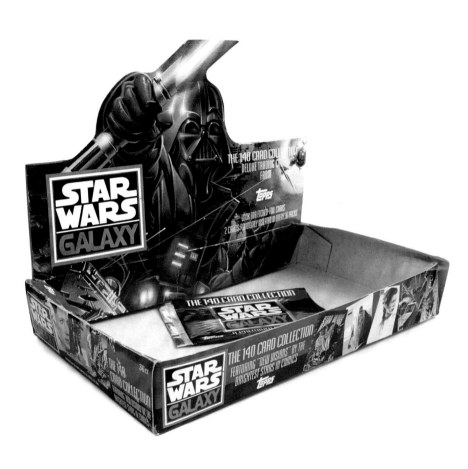

SERIES 1 DISPLAY BOX,
ART BY KEN STEACY, 1993.

approach. Signing on as my collaborator and resident expert on all things *Star Wars* was Stephen J. Sansweet, whose collection of Saga-related goodies is legendary. (Steve would go on to author various books on the subject, including *Star Wars: 1,000 Collectibles* for Abrams in 2009, becoming a spokesperson/consultant for Lucasfilm in the process.)

Then, almost out of left field, something unexpected happened. As Steve and I were digging up rare images to use in this set, Topps decided to launch a line of original comic books, yet another response to the seemingly insatiable direct-sales market. Our new editor in chief of this subsidiary, Jim Salicrup, had solid relationships with some of the finest artists in the comics field, many of whom were *Star Wars* fanatics more than eager to render their takes on beloved characters. So the *Galaxy* photo series suddenly became an art series again—or, rather, an artful combination of just about every approach we'd been developing and refining for the past couple of months. With additional time required for these dazzling new visions, we'd miss our initial deadline and really couldn't call the product an anniversary series anymore. But nobody seemed upset by the delay; we all believed that a trading card set of this creative caliber would be worth waiting for.

Although commissioning great art is one thing, the proper organization of it

was something else. In terms of editorial structure, following one's nose seemed the correct way to proceed. As a nod to our serial-like "introduction of characters" featured in the 1977 movie set, "The *Star Wars* Ensemble" was poised to start things off with painted portraits of the now-iconic lead characters. The card backs would feature a movie photo of each character and a brief bio. Slated to render these full-color goodies was Joe Jusko, whose magnificent paintings had graced many a Dark Horse comic book cover. Bad luck struck, and Joe was suddenly unavailable; good luck came to the rescue in the aging but feisty form of famed Hollywood movie poster painter Joseph Smith, eighty-three at this juncture but still a creative force to be reckoned with. In a way, this last-minute substitution seemed to bring everything full circle . . . Smith was most famous for his 1959 *Ben-Hur* poster campaign featuring Charlton Heston, promoting the quintessential movie epic of its day. Now this same stylistic flavoring was being applied to pop-mythic heroes such as Luke, Han, Chewie, and the rest of the gang (pages 22–33). It's as if the illustrator was creatively linking the Greatest Generation's sensibilities to the decidedly more irreverent sensibilities of the baby boomers. In any

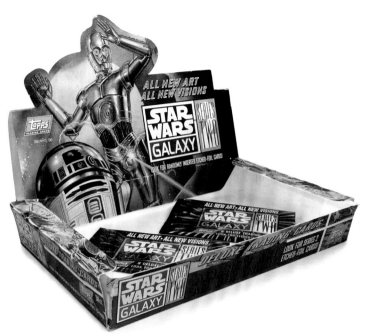

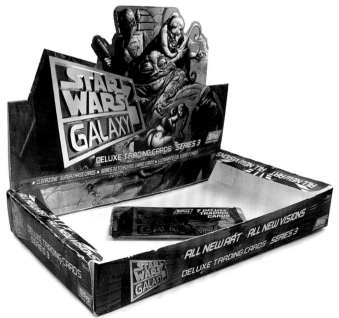

SIDE PANELS FROM TOPPS TRADING CARD DISPLAY BOXES.

event, George Lucas was so enamored with Joe's work that he bought all twelve portraits for his private collection after we published them.

Next in our lineup was "The Design of *Star Wars*," which showcased the great conceptual renderings of Ralph McQuarrie, Ron Cobb, Joe Johnston, and dozens of other fine craftsmen and dreamers who worked on the films. In a very real sense, this is where the "art" of *Star Wars* truly began. Fortunately for our trading card needs, Lucasfilm had great coverage of these invaluable contributions, allowing us to create a visually stimulating "making of" subset.

"The Art of *Star Wars*" followed "Design," and this section focused on art used to promote the three movies and their spin-offs. It was an equally significant subtheme, as the striking Brothers Hildebrandt's rendering of heroic Luke and Leia became instantly iconic, influencing posters for similar movies throughout the 1980s. Renderings for domestic and international cinema, one-shots, and all manner of tie-ins, along with advertising art created by companies lucky enough to have snagged a Lucasfilm license, made charmingly diverse subjects for *Galaxy* trading cards. Best of all, these illustrations were free to use, since rights had been cleared ahead of time and were all owned by Lucasfilm.

Finally, the third and most original subset was the climax of *Star Wars Galaxy*—original, in that a plethora of top artists were allowed to strut their creative stuff in the service of what we called "New Visions." Cool as Joseph Smith's opening portraits were, these "New Visions" illustrations would push the imaginative envelope in a number of significant ways. Although some might be takes on familiar characters in recognizable situations, others would feature fascinating scenes that never happened, or moments that were mentioned in the movies but never visualized on film. "This was our contribution to the art history of *Star Wars*," New Product Development creative director Len Brown remembers with pride. Adding to the experience, card backs were designed to accommodate engaging portraits and mini-bios of the various artists.

So the work commenced, in all creative areas. Hired to coordinate and fine-tune incoming art was Sean Taggart, who also bravely trafficked this complex project through the daunting Topps production system. It was Sean who filed invoices, managed the schedules of the various contributors, and made sure deadlines were met. Meanwhile, bringing his own considerable expertise to our endeavors was trading card designer Arnie Sawyer. Working with NPD art director Brad Kahlhamer, Arnie took our series-within-a-series format and ran with it, enhancing the product's persona with many original

TOP VIEW OF SERIES 1 DISPLAY BOX, ART BY KEN STEACY, 1993.

TOP VIEW OF SERIES 2 DISPLAY BOX, ART BY BORIS VALLEJO, 1995.

layouts and coloring schemes. For the chase cards, which were extra offerings independent of the main set, comic book legend Walt Simonson depicted exciting character renderings that, when pieced together like a puzzle, would form an even more exciting collage (pages 208–09). At the same time, ever-busy Steve Sansweet and I split all of the text-writing chores, which were far more involved than usual for a trading card series.

With some fanfare and much hope, *Star Wars Galaxy* finally debuted in 1993. It did great business in the direct market, won industry awards ("Gummies," among others), and consumers seemed to appreciate all the tender loving care that was put into the set. It was a truly exhausting endeavor for everyone concerned but one we were all very, very proud of. Not only did it reinvigorate *Star Wars* in the world of collectible trading cards, launching a whole new era of Saga-related sets, it also enabled Topps to make a lasting impression in the specialized market it was determined to tap.

So the Force was with us again, big-time. Not surprisingly, the company asked for a follow-up series almost immediately. Overwhelmed but undaunted, we hardy souls started all over again, revisiting conceptual elements that had made the first *Galaxy* series so endearing, while also blasting into new creative territory. I was back at the helm as editor in chief/

copy writer/art director, structuring the content, making selections, and pulling all of the diverse subcategories together. Although Sean Taggart had since departed Topps, Brad Kahlhamer assumed the role of managing editor, working closely with "New Vision" artists and making sure Series 2 went through the Topps system smoothly. Steve Sansweet continued to function as consulting editor and overall *Star Wars* guru, once again sharing text-writing chores with yours truly.

Paralleling George Lucas's need to top himself after the original 1977 movie, we decided to embrace *The Empire Strikes Back* for this second "galaxy" offering. Not only was art chosen and designed to reflect this "better the second time" approach, we also worked to give this series its own distinct look. The blue-and-white color scheme for the cards had a chilly, Hoth-like feel (as opposed to the "Tatooine orange" look of our first series). To reflect the intense father-son tone of *Empire* was a dramatic, face-to-face study of Darth Vader and Luke Skywalker by illustrator Don Punchatz (page 93), which we used as our title card. Other subsets included a Ralph McQuarrie tribute (which boasted four brand-new paintings), a special section on the various comic book incarnations of *Star Wars*, and selected goodies from William Plumb's extensive memorabilia collection. The latter included everything from Alec Guinness's portrait to political cartoons of

Ronald Reagan and his Strategic Defense Initiative (SDI) by Tony Auth.

Of course, original production and promotional art continued to play a key role in our card overview. And, happily, the success of Series 1 allowed our "New Vision" commissions to be increased by a third. Among these original works was a final rendering by the late, great Jack Kirby, Marvel Comics's most celebrated innovator. Walt Simonson returned with another nifty chase card collage (which fit together with his Series 1 rendering to form a superdramatic vista), while fantasy specialist

Boris Vallejo painted our signature "key art"—an unusually active, character-rich portrayal of the droids under attack.

The result of all this impressive work was another successful series. "I thought the *Empire* angle of our second *Galaxy* set was a really smart idea," observed Ira. "A follow-up product was inevitable, and a real challenge to everyone who worked so hard on the first two. What could we do to be different the third time around?"

An Ewok-centric series? Not exactly the creative route we wanted to take. To begin with, it would be somewhat boring

TOP VIEW OF A SERIES 3 DISPLAY BOX, ART BY SIMON BISLEY, 1995.

and predictable to celebrate *Return of the Jedi* for Series 3, mirroring our embrace of all things *Empire* for our second set. A major shake-up of our overall series structure seemed in order. Yes, we would retain various subsets, and, yes, great artists would once again be contributing their original work to "New Visions." This time, however, these renderings would appear in different sections reflecting their specific themes, as opposed to being grouped all together. Since we'd put a spotlight on Ralph McQuarrie's exquisite production art in our previous set, it seemed logical to focus on the promotional creations of superstar illustrator Drew Struzan for this new series. Dazzling art created for *Star Wars* novels published by Bantam Books was included in another subset, Dark Horse and Marvel comics were revisited, and watercolor illustrator Russell Walks wrote and rendered an impressive nine-card overview of philosopher Joseph Campbell's influence on George Lucas's brainchild (pages 166–74). The chase cards for Series 3 were decidedly different as well; they included foil-etched LucasArts tie-ins and "Agents of the Empire" Clear Zone cards, rendered by white-hot artists from Image Comics (pages 201–06).

And that was apparently that . . . at least for the time being. The success of Topps's three *Galaxy* series would inspire a plethora of additional *Star Wars* card sets over the next few years, including our highly acclaimed anamorphic photo line in 1995. I wrote and edited two trade paperback books covering the making of *Star Wars Galaxy* (page 18). These were released by Topps in 1993 and 1994, with director of publishing Greg Goldstein (later the president of IDW Publishing) heavily involved. It would be a couple of decades—a new century, actually—before Topps would ask me to revisit my favorite faraway galaxy for three new art sets based on our venerable trading card formula, now reflecting George Lucas's movie prequels along with the classic trilogy. All of them were commercial and creative hits, I'm delighted to report.

So, is there a future for art-themed trading card sets relating to *Star Wars*? How could there not be? What writer-director George Lucas unleashed in 1977 became part of our shared mythology, and the popularity of *Star Wars* certainly shows no signs of letting up. Everything about this imaginative saga lends itself to flamboyant, often classical, always inspiring creative interpretation, from the designs of the artists working on the movies to inspirational renderings for promotional tie-ins and original galleries of fans and pros alike. As ringleader for this colorful trading card overview since 1993, I've been pleased to bring *Star Wars Galaxy* into the lives of all who cherish it.

May the artistic force continue to be with all of us!

GARY GERANI is a screenwriter, author, noted film and TV historian, and children's product developer. He is best known for the Stan Winston–directed horror-movie classic *Pumpkinhead*, which he co-wrote; his groundbreaking 1977 nonfiction book *Fantastic Television*; and the literally hundreds of trading card sets that he's created, edited, and written for the Topps Company since 1972. His graphic novels include *Dinosaurs Attack!* (inspired by his own Topps trading cards) and *Bram Stoker's Death Ship*, an untold story of the Dracula legend. He also has his own publishing unit, Fantastic Press, in partnership with the popular comic book company IDW. Gerani lives in California.

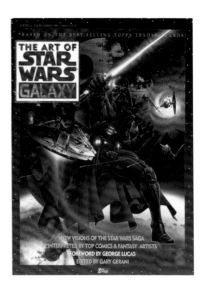

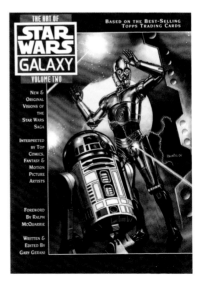

TOP AND BOTTOM: THE COVERS OF *THE ART OF STAR WARS GALAXY, VOLUME 1* (1993), FEATURING ART BY KEN STEACY, AND *THE ART OF STAR WARS GALAXY, VOLUME 2* (1994), FEATURING ART BY BORIS VALLEJO, BOTH PUBLISHED BY TOPPS.

OPPOSITE: PROMOTIONAL INSERT FROM DIAMOND *PREVIEWS* FOR *STAR WARS GALAXY* SERIES 1, FEBRUARY 1993, ART BY THOMAS WM. YEATES II.

THE 140 CARD COLLECTION

STAR WARS GALAXY

topps. 8 PREMIUM CARDS
LOOK FOR ETCHED-FOIL CARDS!

SERIES ONE

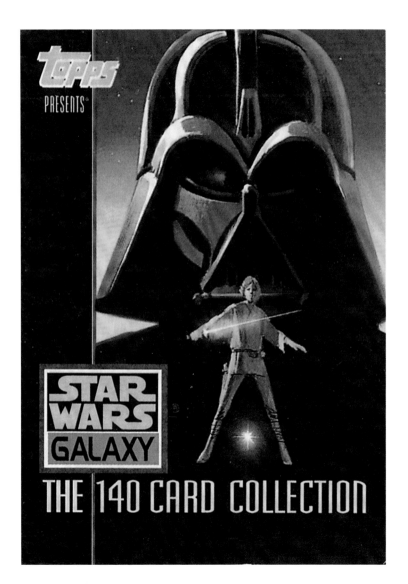

Title card, art by **Ralph McQuarrie**.

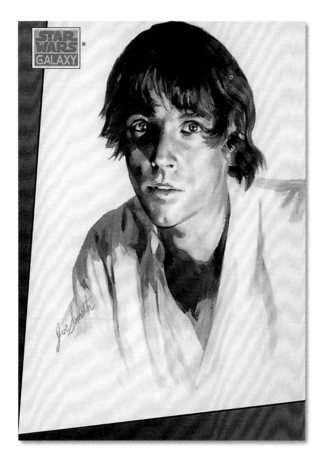

Painter **Joseph Smith**, famed for his *Ben-Hur* movie poster and iconic Hollywood portraits, tackled George Lucas's seminal sci-fi characters for our first *Star Wars Galaxy* series (pages 22–33). Lucas was so impressed that he purchased all twelve of Smith's originals, which were proudly displayed in the filmmaker's northern-California offices.

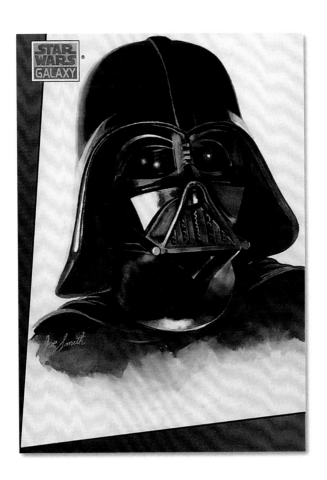

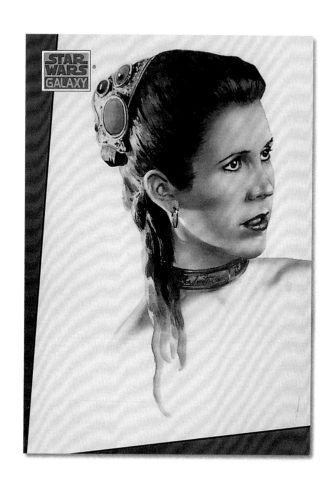

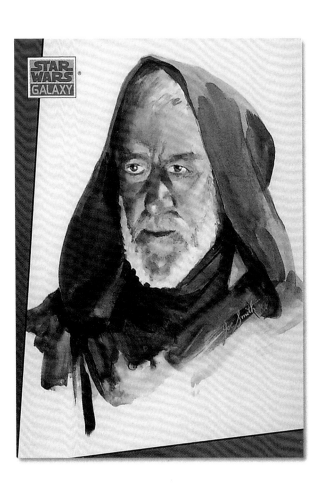

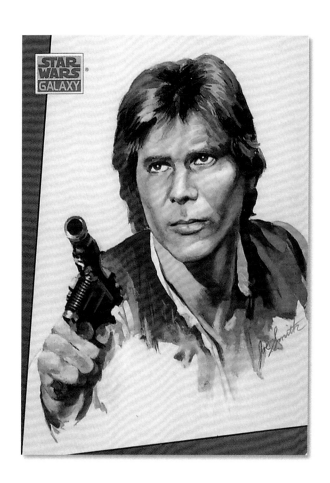

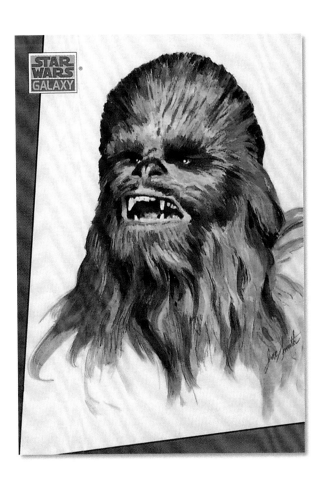

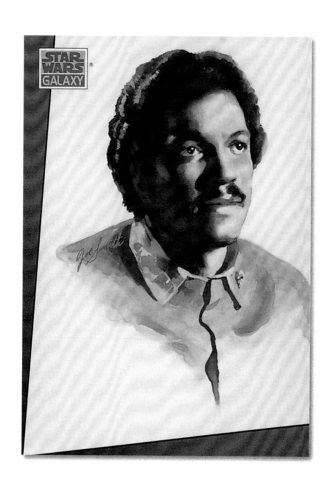

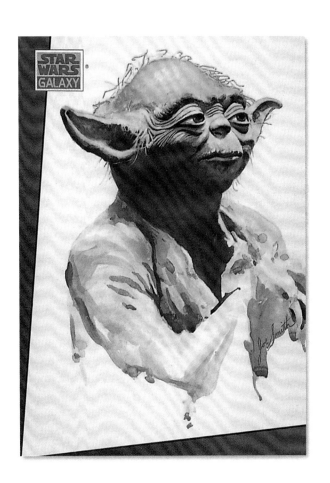

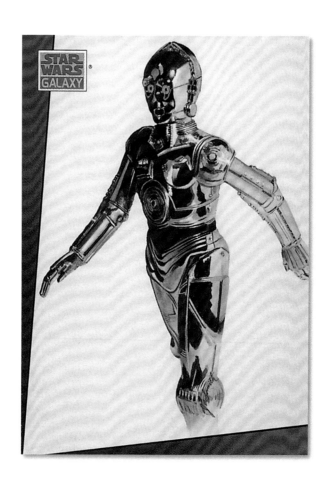

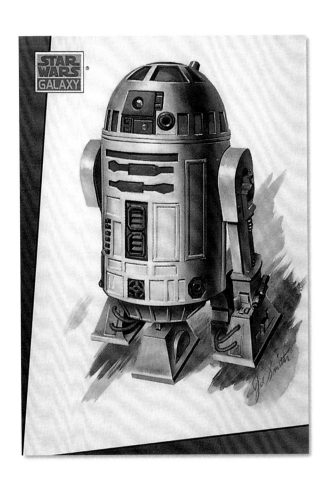

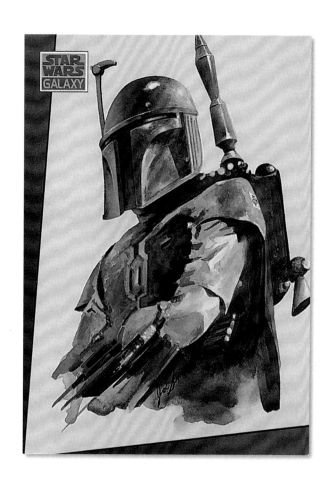

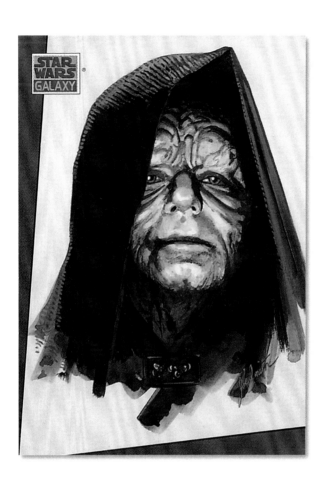

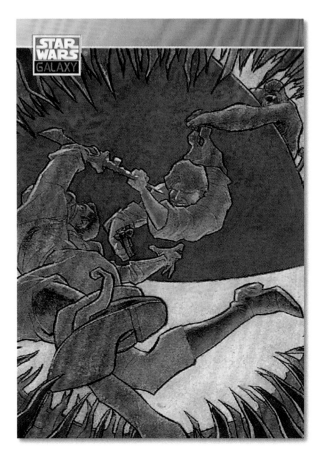

Kyle Baker depicted Han, Chewie, and Lando Calrissian holding on for dear life above the dreaded sarlacc in a rendering inspired by *Return of the Jedi*.

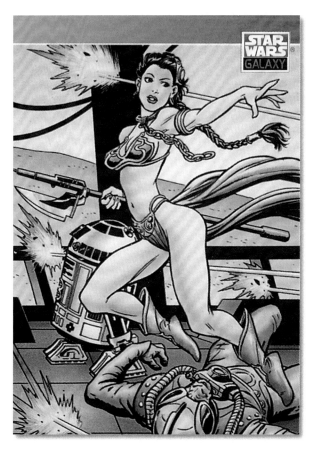

Slave girl Leia Organa strikes back at her oppressors on Jabba's prison barge in this pen-and-ink piece by **Bret Blevins**.

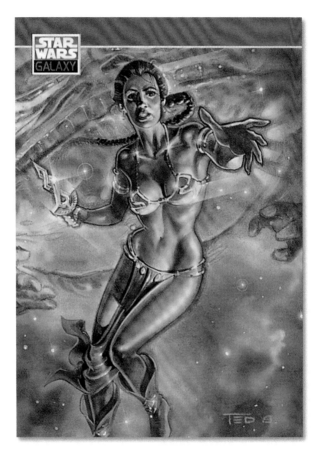

More enslaved Leia in action, this time rendered with markers and colored pencils by **Ted Boonthanakit**.

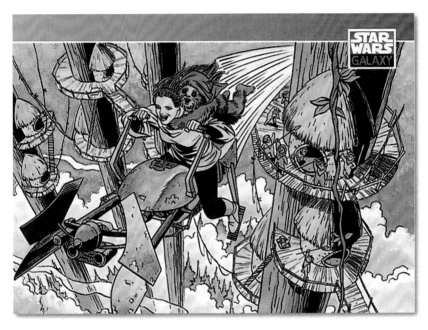

Leia enjoys a speeder bike ride, with pal Wicket in tow, as rendered by **June Brigman** with "pen, black ink, and a good deal of nostalgia," the artist points out.

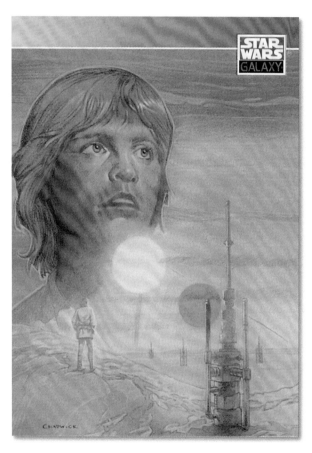

Using colored pencil and acrylics, artist **Paul Chadwick** captures Luke Skywalker's lonely life on twin-sunned planet Tatooine.

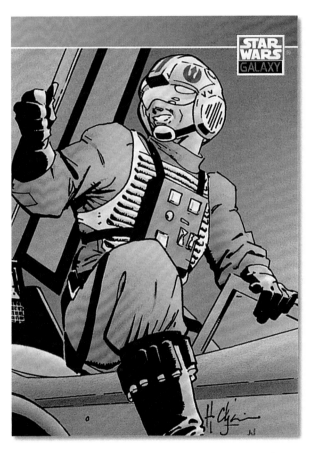

Confident star pilot Luke Skywalker prepares to take on the Empire in this
pen-and-ink rendering by **Howard Chaykin**.

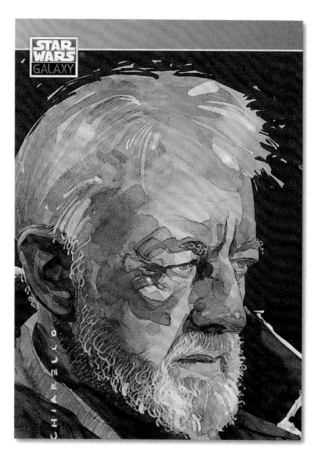

The exquisite watercolor technique of **Mark Chiarello** captured the dignity of Jedi knight Obi-Wan Kenobi in this memorable portrait.

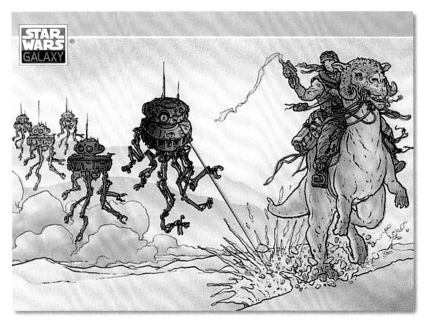

Geof Darrow penciled and inked this exciting probot attack on the icy plains of Hoth, a scene inspired by *The Empire Strikes Back*.

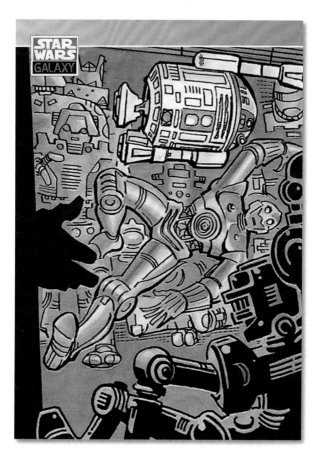

A fanciful look at fugitive droids under siege by **Steve Ditko**, the reclusive comic book legend famed for Spider-Man and other Marvel greats.

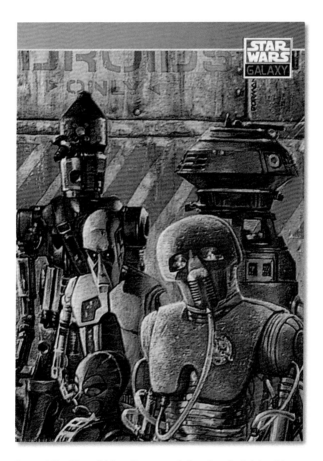

Frequent *Star Wars* artist **Dave Dorman** used oils and acrylics to bring this group-shot study of various droids to life.

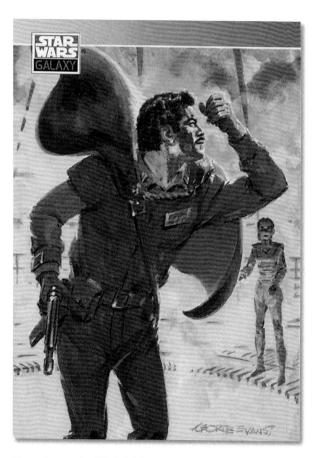

George Evans captured the hellish flavor of the carbon-freeze sequence from
The Empire Strikes Back with acrylics and colored pencil.

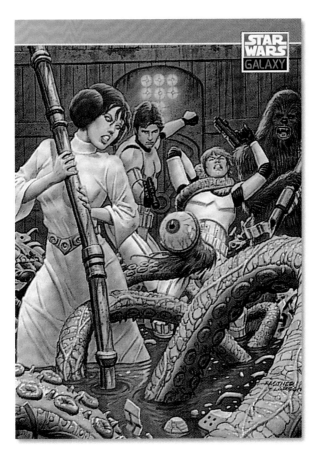

Han, Luke, Leia, and Chewie face a flattening death from a trash compactor and dreaded diagona monster in this endearing **Steve Fastner** and **Rich Larson** painting.

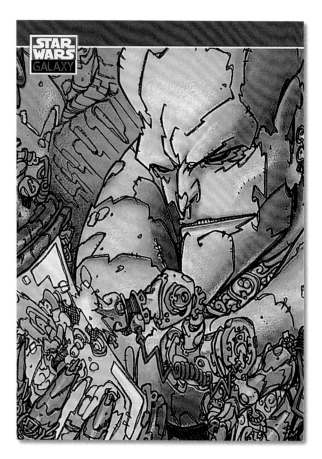

Keith Giffen used his striking line-work technique to bring to illustrated life the offbeat Bib Fortuna from *Return of the Jedi*.

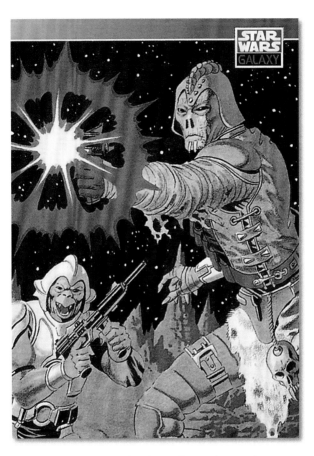

Paul Gulacy employed Cel vinyl, markers, and watercolors to render mercenaries from *Return of the Jedi*'s sail-barge sequence.

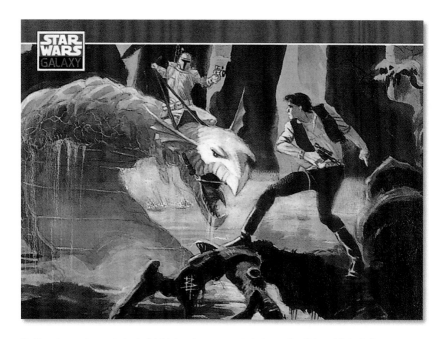

Bo Hampton used gouache to depict this imaginary encounter between Han Solo and Boba Fett on Dagobah.

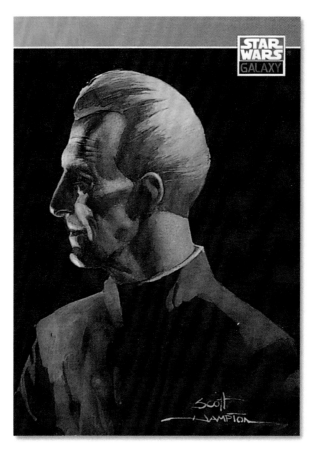

This dramatic portrait of Grand Moff Tarkin was rendered by **Scott Hampton** using mixed media (ink, oils, watercolors, and colored pencil).

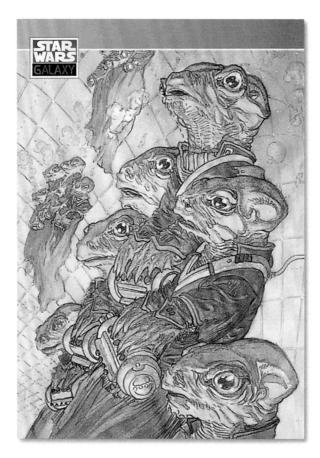

Michael Kaluta breathed life into the early days of Admiral Ackbar and his aquatic classmates with ink and watercolors.

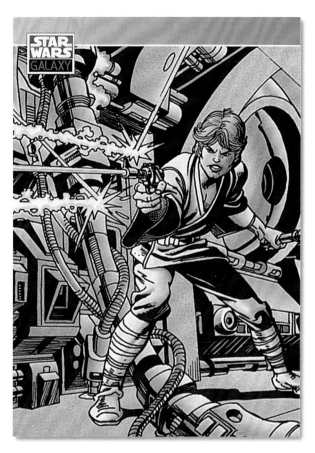

Veteran comics artist **Gil Kane** (cocreator of Green Lantern and the Atom) penciled and inked this heroic portrait of blaster-packing Luke Skywalker.

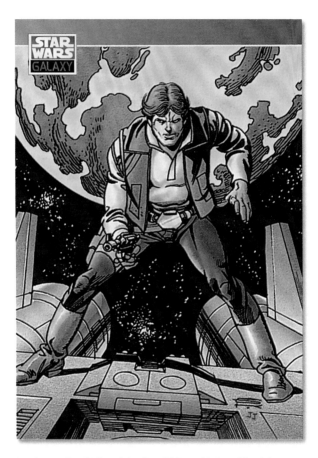

Another pencil-and-ink rendering from **Gil Kane**, this time of Han Solo.

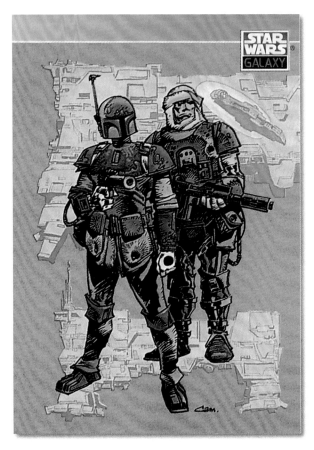

Using pen and ink, **Cam Kennedy** took a crack at two nefarious bounty hunters, Boba Fett and Dengar, from *The Empire Strikes Back*.

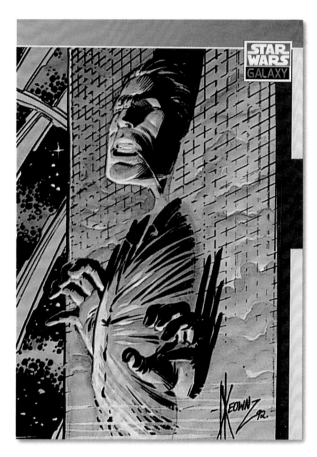

In this dramatic ink-and-paint rendering, **Dale Keown** captured the agony of carbon freeze as suffered by Han Solo.

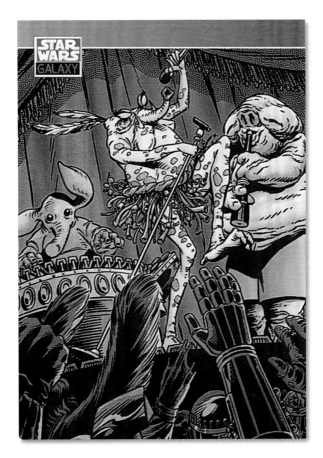

Karl Kesel rendered this pen-and-ink "snapshot" of Sy Snootles and the Max Rebo Band in Jabba the Hutt's festive throne room.

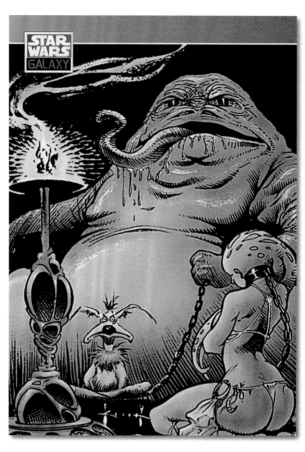

Jabba the Hutt of Tatooine and his odious, bird-like companion Salacious B.
Crumb were realized by **Sam Kieth** in this inked rendering.

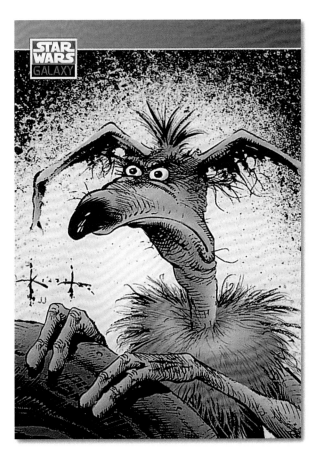

Another inked rendering of Salacious B. Crumb by **Sam Kieth**.

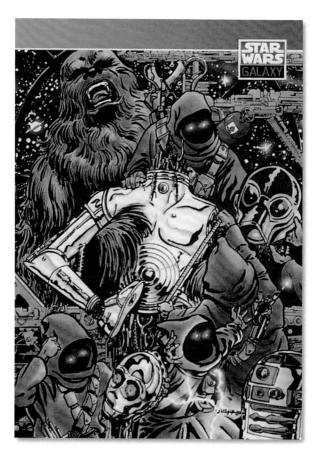

C-3PO is beside himself in a wacky illustration by **David Lapham**, who included Chewie, R2-D2, and the Jawas for added mayhem.

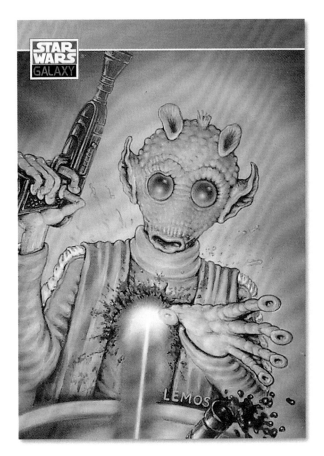

Painter **Mike Lemos** gets right to the point in this over-the-table interpretation of Greedo's demise from *Star Wars*.

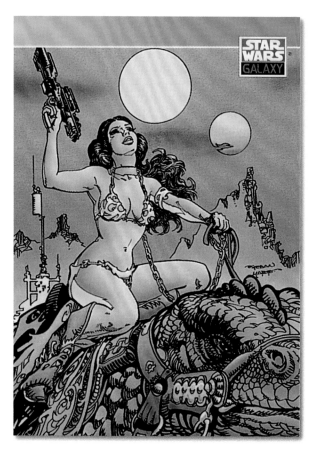

Esteban Maroto saw the sexy side of Princess Leia, astride a dewback, in this pen-and-ink illustration set on twin-sunned Tatooine.

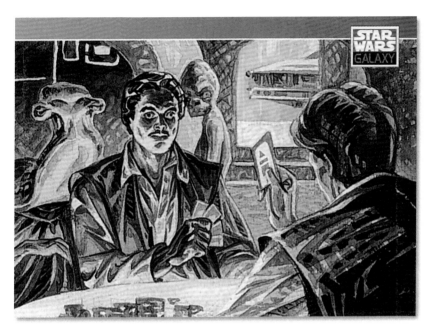

Cynthia Martin used pencil and gouache to realize the moment when Lando Calrissian lost the *Millennium Falcon* to Han Solo in a card game.

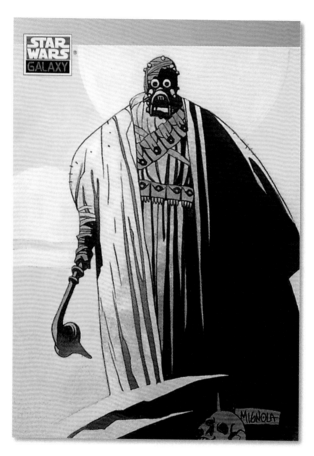

Hellboy creator **Mike Mignola** turned his considerable pen-and-ink skill to this depiction of an imposing Tusken Raider on Tatooine.

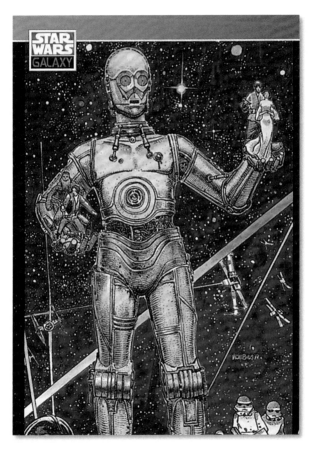

Jean "Moebius" Giraud, famous for his conceptual work on *Alien*, envisioned (in acrylics and gouche) a C-3PO–centric *Star Wars* galaxy.

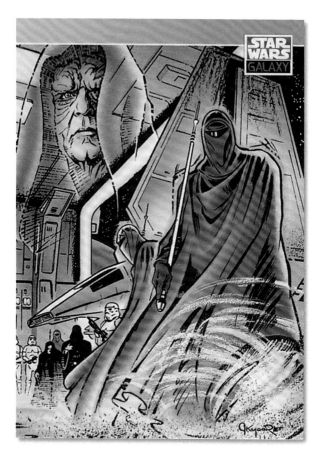

The elegant Royal Guards of the Emperor, as seen in *Return of the Jedi*, inspired this ink rendering by **Jerome Moore**.

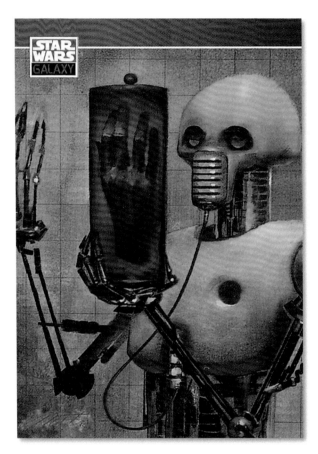

Jon J Muth (long before he became a celebrated children's book creator) used a potent combination of oils, graphite, charcoal, and silverpoint to realize the surgeon droid and his prize—Luke's hand.

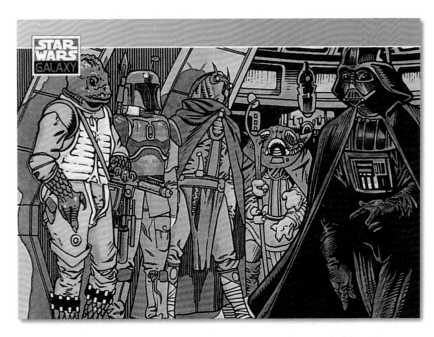

Darth Vader assembles his rogues' gallery of bounty hunters, as illustrated in pen-and-ink by **Mark Nelson**—a self-confessed "creature" fanatic.

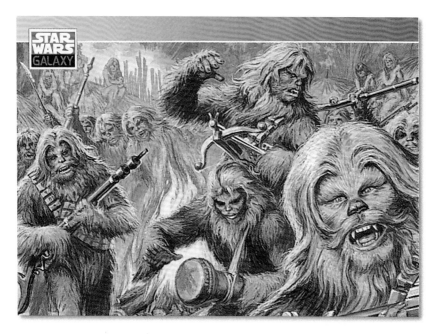

Veteran painter **Earl Norem** unleashed a tribe of Wookiees doing a war dance in an exciting scene that was never filmed.

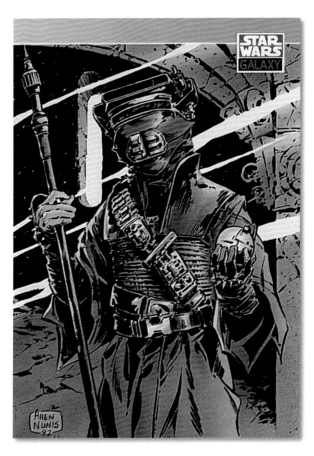

Princess Leia disguised as Boushh, the bomb-toting bounty hunter, inspired some intricate pen-and-ink work from **Allen Nunis**.

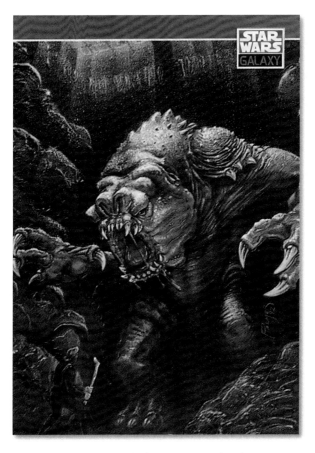

Jason Palmer decided to render the fearsome rancor with acrylics on illustration board, which was primed with gesso for added luster.

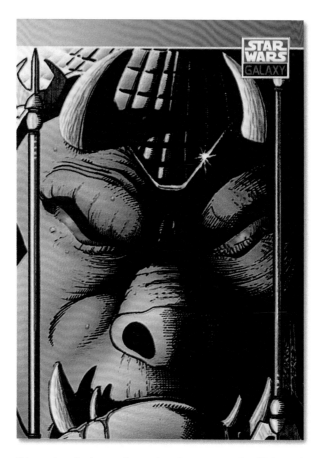

This very dramatic close-up of a monstrous Gamorrean guard enabled Marvel artist **George Pérez** a chance to experiment in pen and ink.

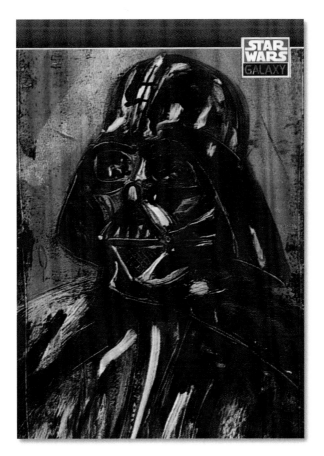

George Pratt used the monotype process (reverse printing on oils) to realize this striking portrait of Darth Vader.

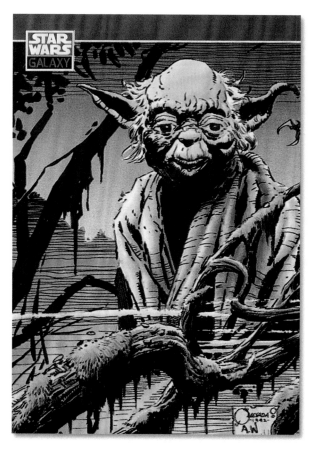

Enigmatic Yoda on the swamp world Dagobah was penciled by **Joe Quesada** (long before he was editor in chief of Marvel Comics) and inked by veteran comics illustrator **Al Williamson**.

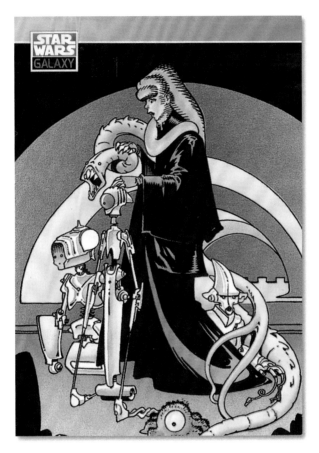

Artist **P. Craig Russell**'s ornate, fanciful line technique worked wonderfully for Bib Fortuna and his equally bizarre companions.

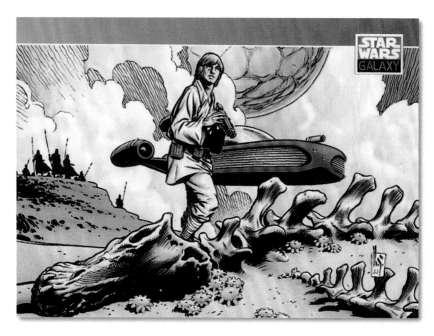

Luke's bleak but exotic life on planet Tatooine is cleanly conveyed in ink and brush by **Mark Schultz** (creator of *Cadillacs and Dinosaurs*), a self-proclaimed "traditionalist."

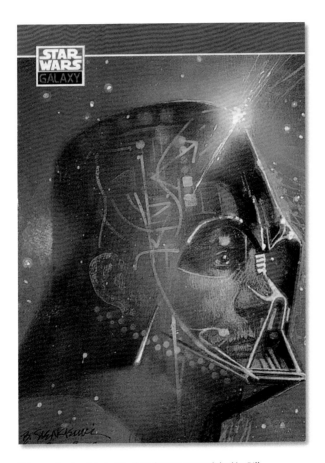

This revealing head shot of Darth Vader was accomplished by **Bill Sienkiewicz** with watercolor, acrylics, "and sweat," adds the artist.

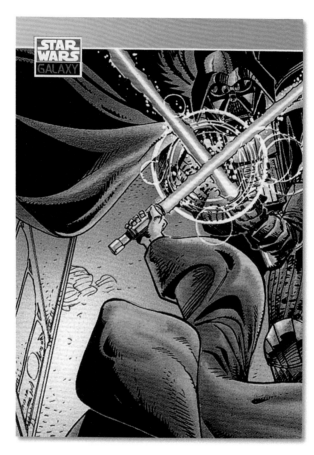

Walter Simonson captured the high-stakes excitement of Obi-Wan's clash with Vader aboard the Death Star in this pen-and-ink rendering.

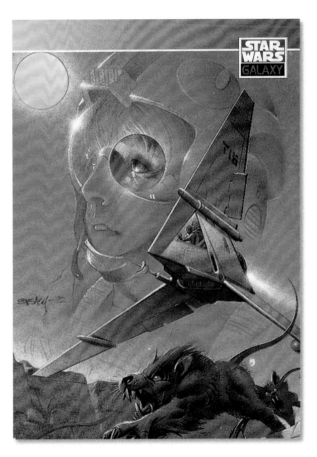

Using colored pencils and acrylics, **Ken Steacy** not only rendered Luke's T-16 skyhopper, but also showed *Star Wars* fans what a womp rat looked like.

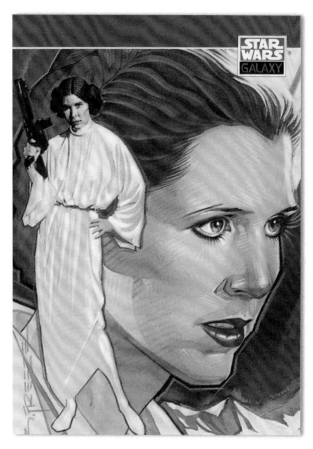

Brian Stelfreeze employed techniques used by Flemish masters (replacing oils with acrylics) to create this compelling portrait of Princess Leia.

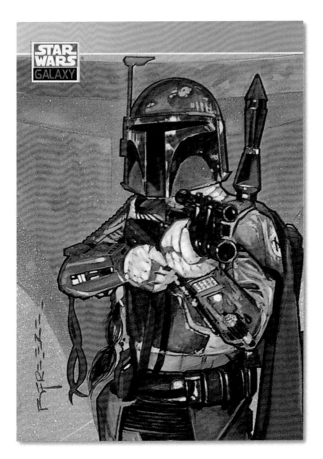

A portrait of bounty hunter Boba Fett, also by **Brian Stelfreeze**.

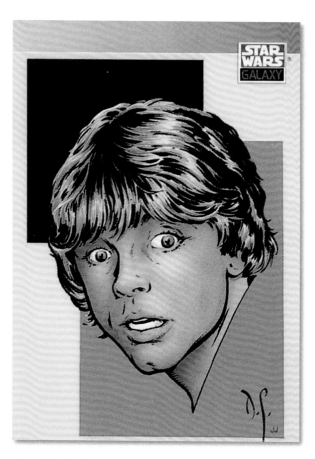

Through this inked head study, Rocketeer creator **Dave Stevens** captured
Luke Skywalker's wide-eyed sense of wonder.

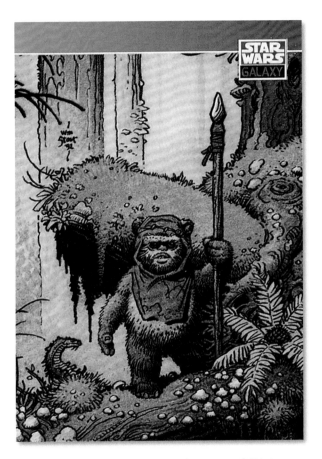

Inks and watercolors were used in this atmospheric portrait of Wicket, an Ewok on Endor's forest moon, as rendered by celebrated fantasy artist **William Stout**.

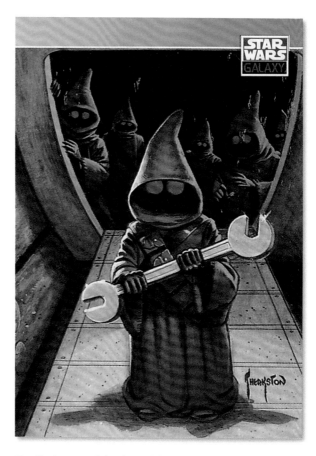

Greg Theakston penciled and painted this bold portrait of a feisty little Jawa, who is given tentative support by his hooded companions.

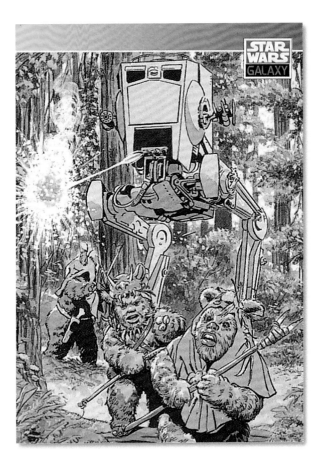

Ewoks under Imperial attack as envisioned by *MAD* Magazine artist **Angelo Torres**, who is most comfortable using watercolors and colored inks over an inked line drawing.

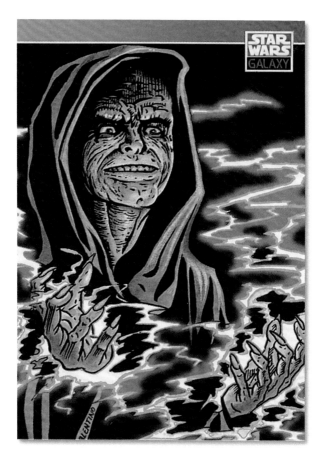

Pen-and-ink artist **Jim Valentino** viewed his subject, the evil Emperor Palpatine, as "an old-line sorcerer in high-tech surroundings."

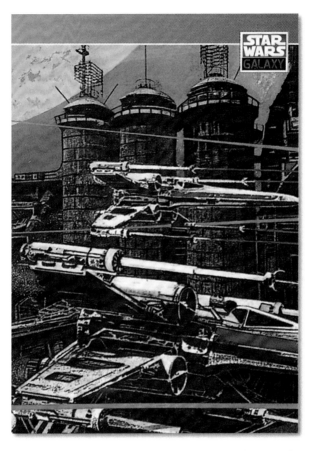

Using mixed media (xerography and a belt sander), **John Van Fleet** captured the high-speed drama of Rebel X-wing fighters on a raid.

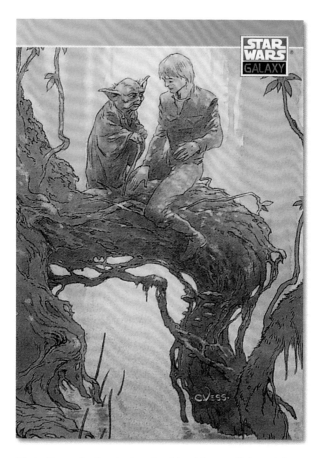

Charles Vess used watercolors to capture this quiet moment between Luke Skywalker and instructor Yoda on the swamp world Dagobah.

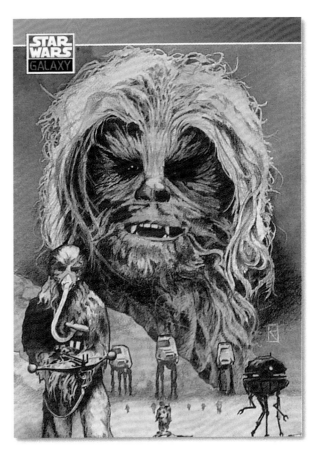

Chewbacca, as seen in *The Empire Strikes Back*, was illustrated by **Russell Walks** in watercolors and colored pencil.

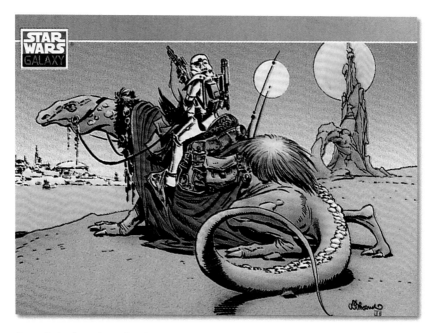

Known for his elegant line and *Flash Gordon* comic-strip renderings, **Al Williamson** provided these two vistas of Imperial troopers in diametrically opposite environments.

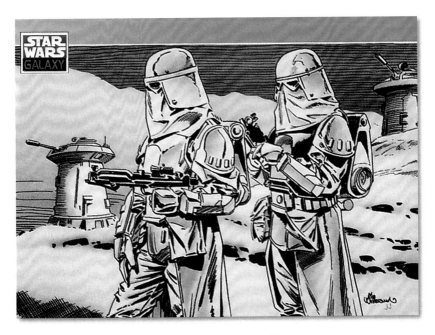

Al Williamson's second illustration of Imperial troopers, this time on Hoth.

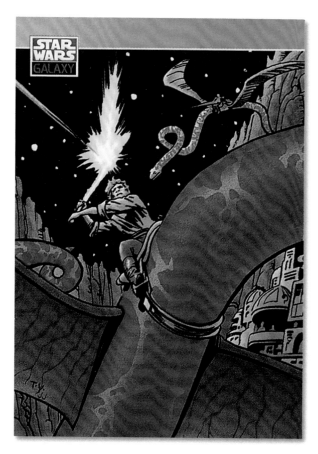

Thomas Wm. Yeates II used inks to illustrate Luke Skywalker atop a giant winged serpent, a concept inspired by the *Star Wars* newspaper strip.

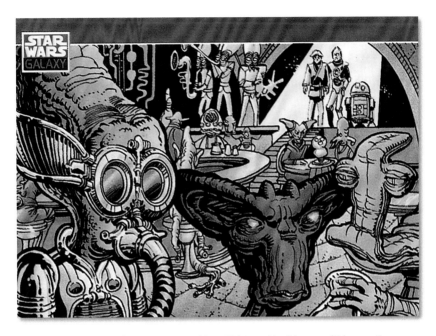

The bizarre, bustling Mos Eisley cantina prompted **Bruce Zick** to envision this pen-and-ink re-creation.

SERIES 2, 1994

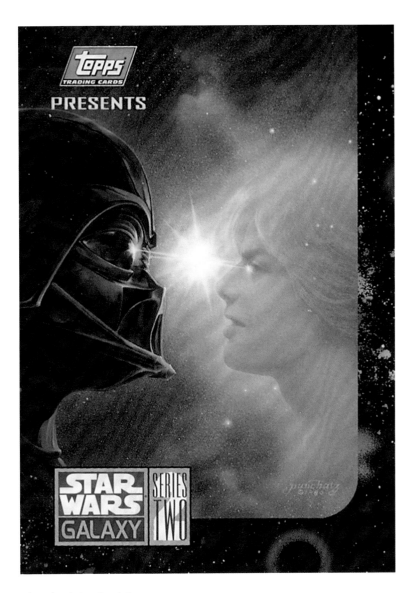

Title card, art by **Don Punchatz**.

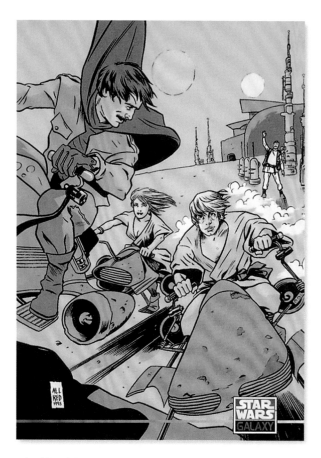

Luke's life with best pal Biggs Darklighter and other Tatooine locals was explored by pen-and-ink artist **Michael Allred** (creator of Madman), with colors by **Danny Hellman**.

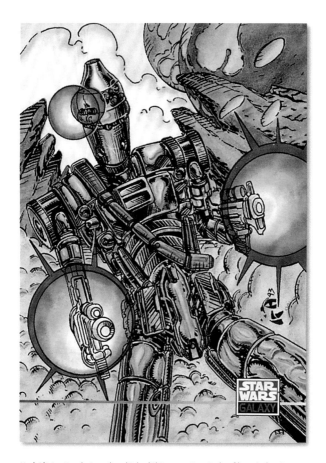

Karl Altstaetter designed and inked this evocative study of bounty hunter droid IG-88, introduced in *The Empire Strikes Back*, with color by **Debbie David**.

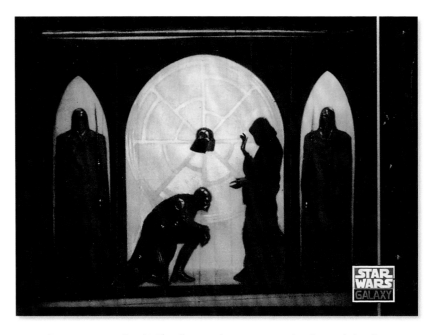

Painter **Thom Ang** envisioned Anakin Skywalker's transformation into Darth Vader years before this event was conceived for film.

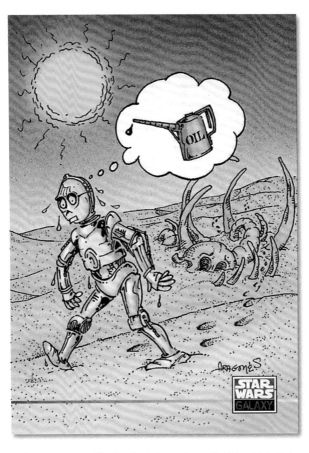

With *MAD* Magazine–like glee, **Sergio Aragonés** provided this satiric look at trouble-prone C-3PO "dying of thirst" in the Tatooine desert.

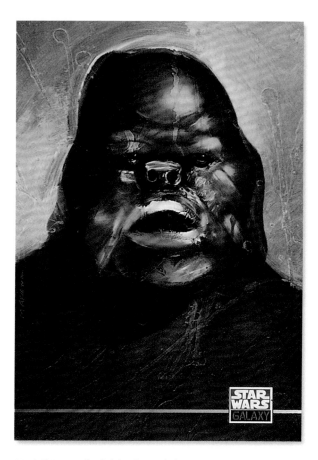

Marshall Arisman decided that the mostly forgotten Ugnaughts needed a little love, so he chose to paint one in gruesome close-up.

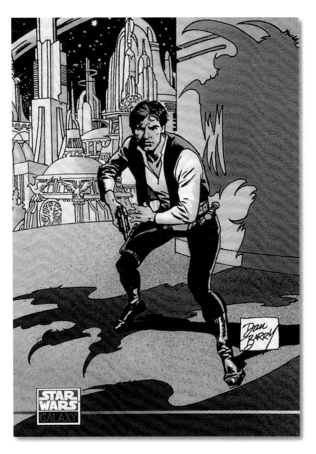

Dan Barry placed Han Solo in an exotic *Flash Gordon*–like environment, merging the fantasy worlds of Alex Raymond and George Lucas. Color by **Mike McPhillips**.

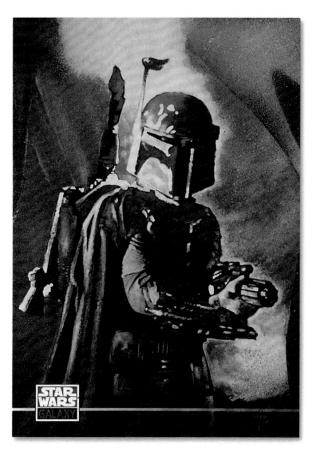

Boba Fett, an enigmatic bounty hunter of few words, springs into action in this striking painting by **John Bolton**.

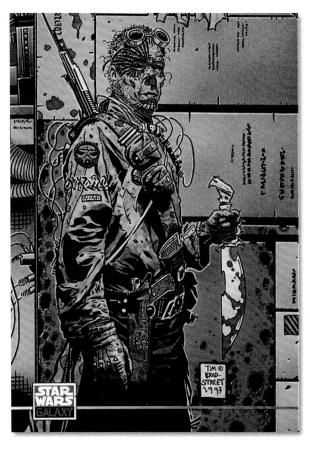

Illustrator **Timothy Bradstreet** created a new, nameless galactic bounty hunter, deftly capturing his every unsavory detail.

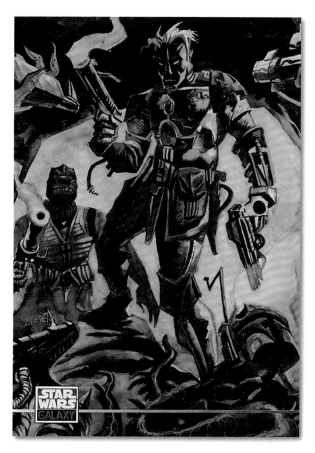

Long before Boba Fett's true appearance was revealed in the prequel *Attack of the Clones*, painter **Dan Brereton** took a crack at what he might look like with this audacious interpretation.

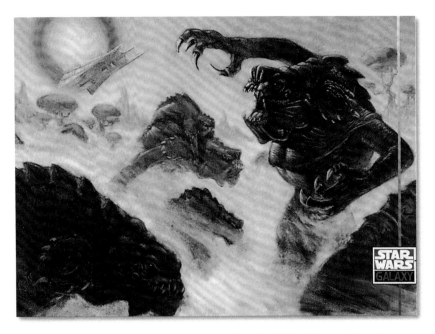

Penciler/painter **Ron Brown** envisioned several wild rancors being herded by Jabba's spaceship in this imaginative Tatooine vista.

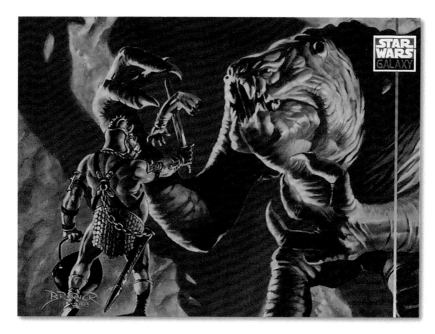

Jabba's personal rancor is fed by a Gamorrean guard in this stunning acrylics painting by comics veteran **Frank Brunner**.

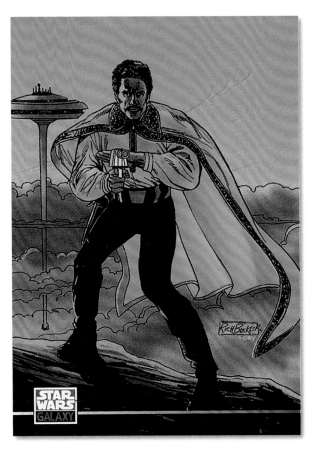

This commanding portrait of Lando Calrissian taking control of Cloud City was rendered by **Rich Buckler**.

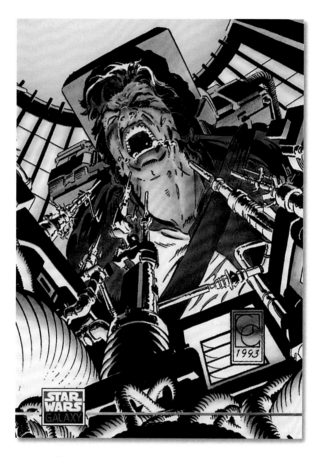

Greg Capullo enjoyed depicting Han Solo's torture because the artist excels at rendering "teeth and spittle." Color by **John Cebollero**.

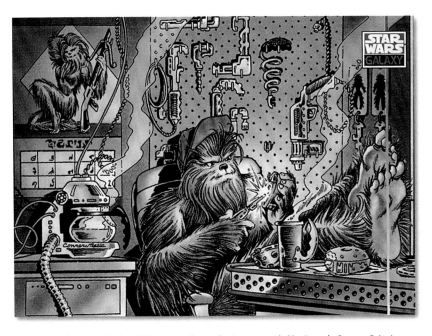

This charmingly cartoonish view of Chewbacca the mechanic was provided by **Amanda Conner**. Color by **Mike McPhillips**.

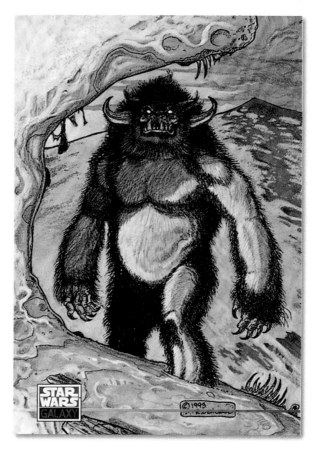

Ricardo Delgado had fun drawing, inking, and coloring the wampa, the horned and horrific abominable snow creature of Hoth.

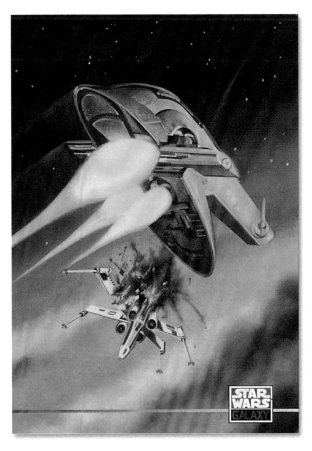

Boba Fett's spaceship, the *Slave I*, wipes out an unsuspecting X-wing in this epic painting by fantasy artist **Joe DeVito**.

Colleen Doran missed out on a chance to render villainous Lumiya for the comics, so she relished this opportunity to create a dramatic, full-figure study.

Using computer technology, **Norm Dwyer** produced this powerful scene of an Imperial AT-AT warding off rebel speeders in a city.

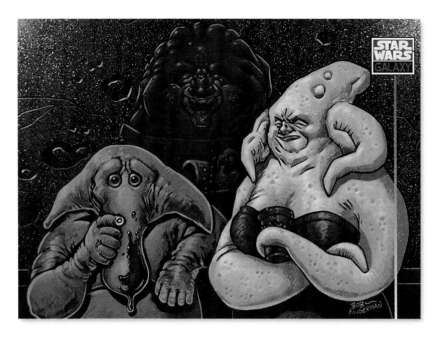

What he defined as the "short, fat, and silly" aspects of Jabba's throne-room denizens appealed to **Bob Fingerman**, who painted three of the creatures in "snapshot" mode.

Hugh Fleming used gouache and acrylics to paint this most complimentary portrait of Alec Guinness as young Obi-Wan.

Illustrator **Franchesco** offered this finely detailed study of C-3PO and R2-D2 within a techno-environment. Color by **John Cebollero**.

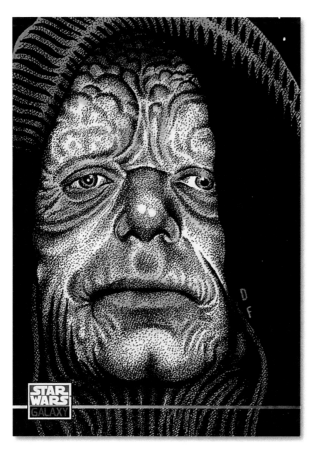

Famed caricaturist **Drew Friedman** found a great deal of inspiration in the multicreviced face of *Return of the Jedi*'s mad emperor, Palpatine. Color by **John Cebollero**.

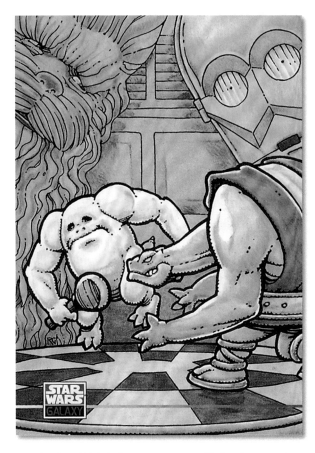

Funny but formidable holochess creatures square off before the awestruck eyes of Chewie and C-3PO in this **Rick Geary** painting.

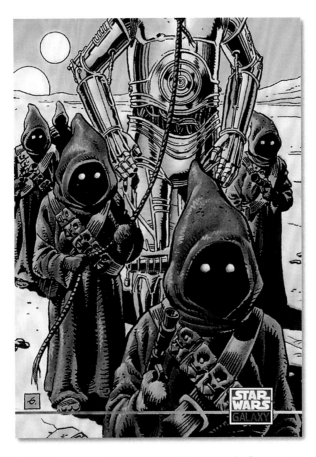

Runaway droid C-3PO becomes a prisoner of the Jawas in this illustration from **Dave Gibbons** (artist of the seminal graphic novel *Watchmen* by Alan Moore). Color by **John Cebollero**.

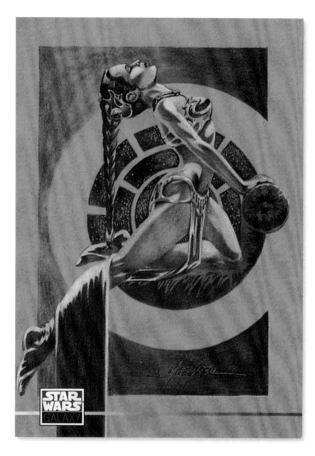

"Sensual rather than sexist" was the self-stated artistic goal of **Mike Grell** in designing this stimulating study of Princess Leia in her slave outfit.

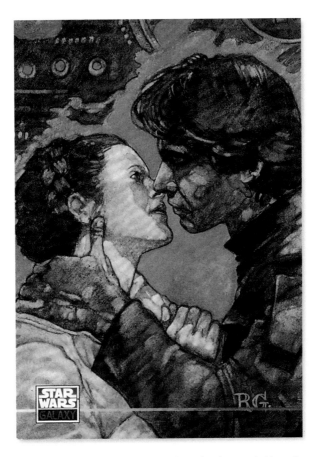

Rebecca Guay used watercolors and related mixed media to render Han and Leia's romance from *The Empire Strikes Back*.

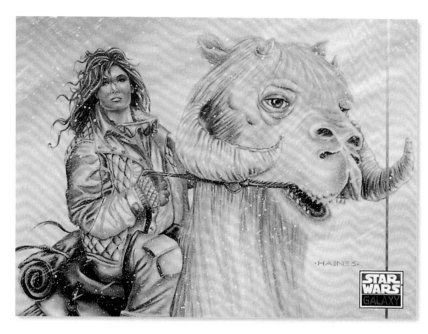

This inspiring image of a female rebel trooper on Hoth, searching for the missing Han and Luke, was designed and colored by **Lurene Haines**.

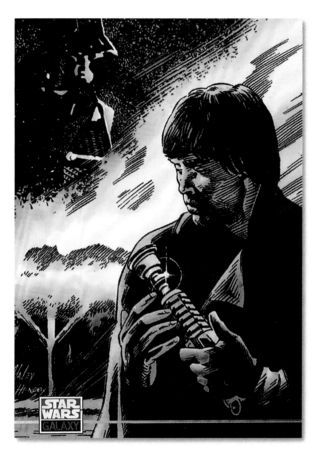

Penciler **Matt Haley** depicted the funeral of Darth Vader and Luke's deep thoughts about his legacy. Inks by **Shepherd Hendrix** and color by **John Cebollero**.

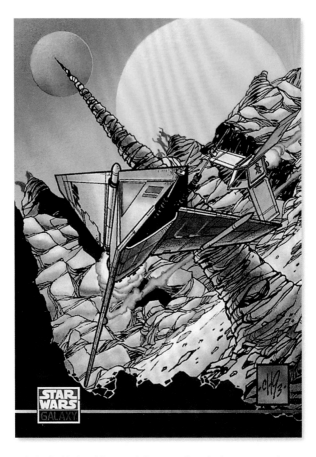

Luke has bad luck with his T-16 skyhopper in the radio dramatization of *Star Wars*, a moment remembered and rendered by **Cully Hamner**.

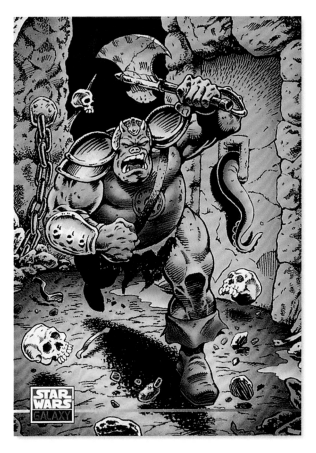

Rich Hedden penciled this outlandish, cartoon-style image of a rampaging Gamorrean guard. Inks and colors by **Mike McPhillips**.

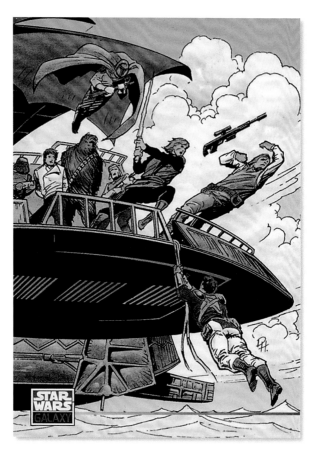

It's Jedi fury and overall mayhem aboard Jabba's sail barge in this energetic line rendering by **Dave Hoover**, colored by **John Cebollero**.

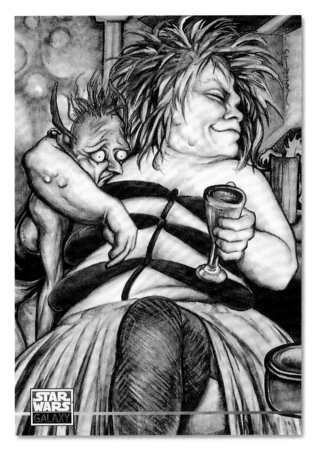

Janine Johnston decided to illustrate party animal Yarna d'al' Gargan from Jabba's palace, because, the artist says, she has always enjoyed "fat, happy people."

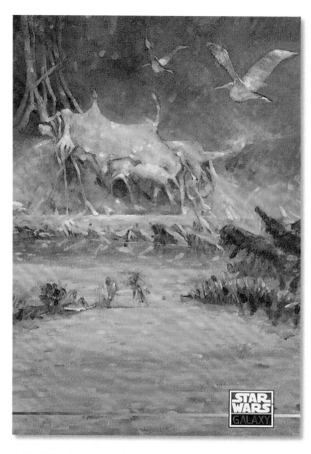

Painter **Jeffrey Jones** saw the beauty, along with the compelling dark mystery, of Yoda's little dwelling on Dagobah.

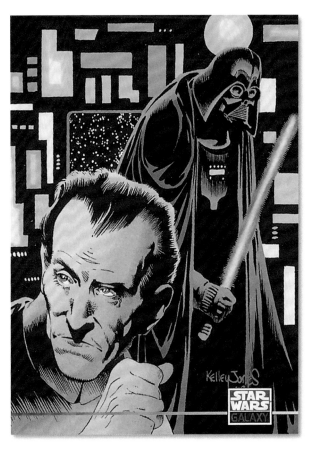

The distinctive facial features of actor Peter Cushing inspired this pencil/ink rendering of Grand Moff Tarkin and Darth Vader by **Kelley Jones**, with color by **Les Dorscheid**.

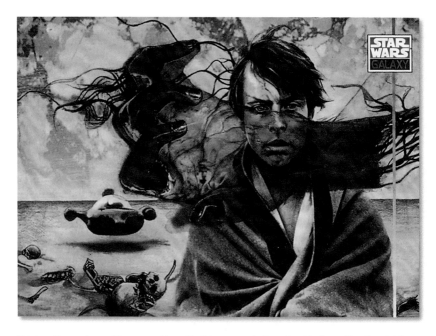

This haunting, soul-wrenching moment from *Star Wars* was perfectly captured by the multimedia art style that **Miran Kim** specializes in.

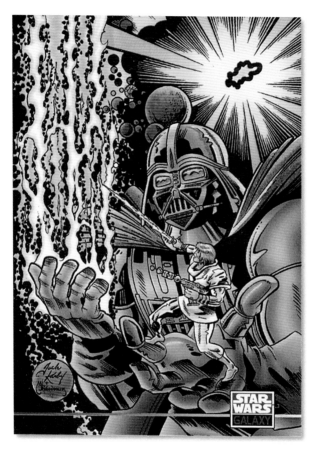

Jack Kirby, the "King of Comics," turned his legendary talents to the *Star Wars* universe, with inks by **Michael Thibodeaux** and color by **Janet Jackson**.

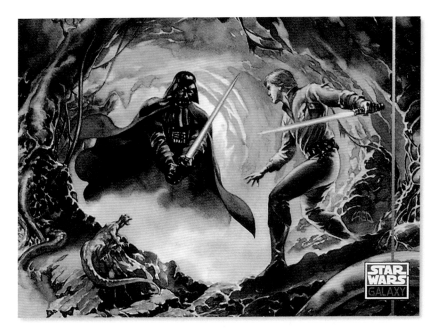

During his training on Dagobah, Luke Skywalker confronts the apparition of Darth Vader—a moment fully realized by painter **Ray Lago**.

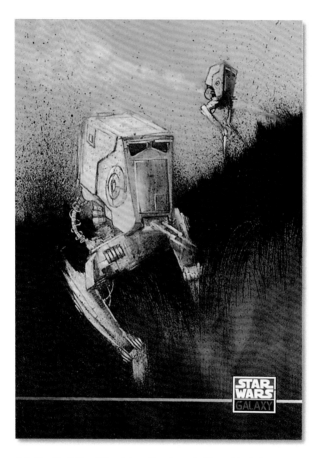

Patrolling the field as if they belong there is a pair of Imperial "chicken walkers," as rendered in fine detail by **Zohar Lazar**.

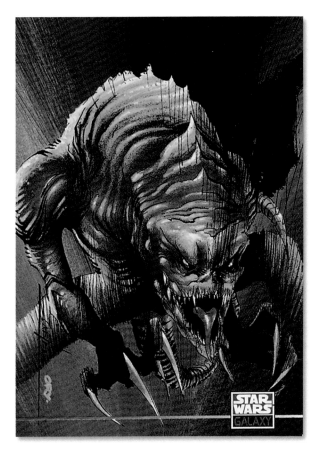

Jae Lee designed and colored this striking rendering of Jabba's pit monster, the flesh-eating rancor, from *Return of the Jedi*.

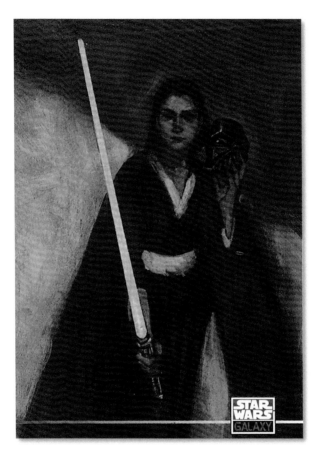

"The mask of Vader indicates that she is of his blood," said artist **Paul Lee** of Leia, who celebrated the young princess's significant heritage with this portrait.

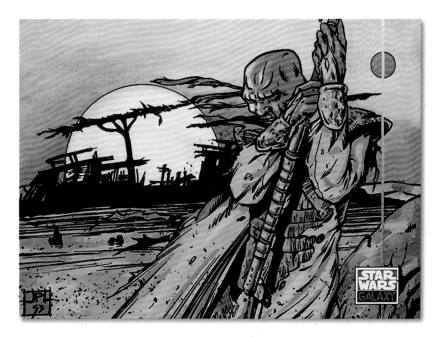

An escapee from the sail-barge disaster inspired **John Paul Lona** to render this image, which was ably supported by **Rebecca Guay**'s colors.

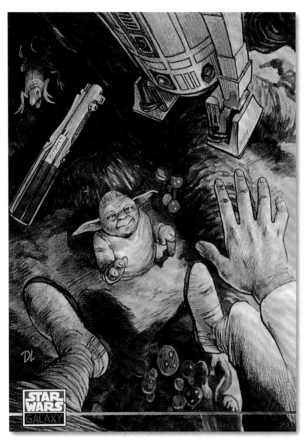

An intriguing point of view from levitated Luke informs this painting by
David Lowery, who included several floating objects in his composition.

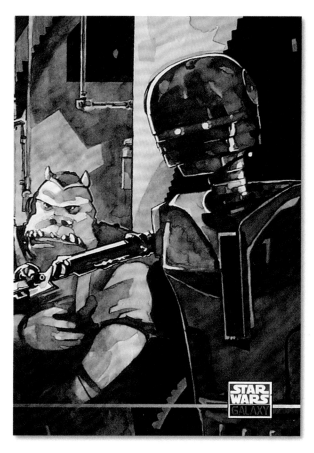

Shawn C. Martinbrough used inks and watercolors to convey the atmosphere of doom surrounding Jabba's torture chamber.

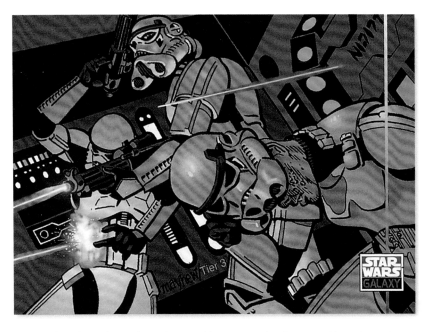

Penciler/inker **Mike Mayhew** took an early, reasonably accurate peek under an Imperial stormtrooper's helmet.

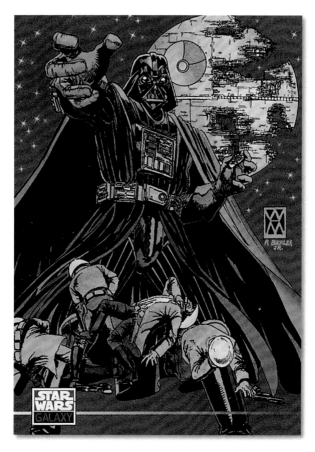

Illustrator **Walter McDaniel** found himself "caught in the grip" of Darth Vader's influence. Inks by **Rich Buckler** and color by **John Cebollero**.

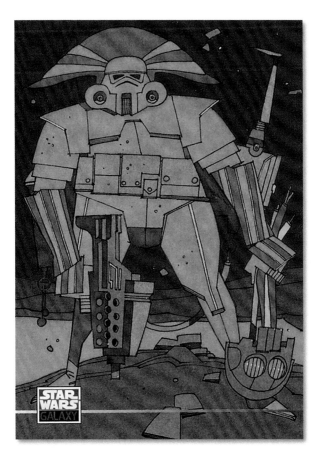

Star Wars went abstract with this notable **Mike McMahon** creation, which boasts a no-nonsense stormtrooper and his recent droid victim.

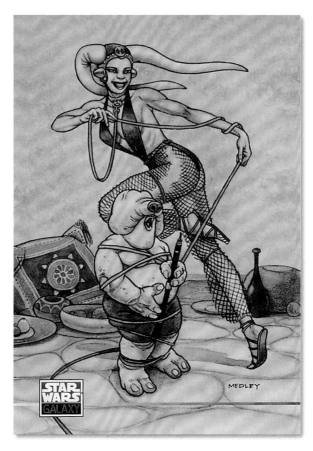

Jabba's palace performers Droopy McCool and dancing slave girl Oola were lovingly rendered and colored by **Linda Medley** (creator of the fairy tale *Castle Waiting*).

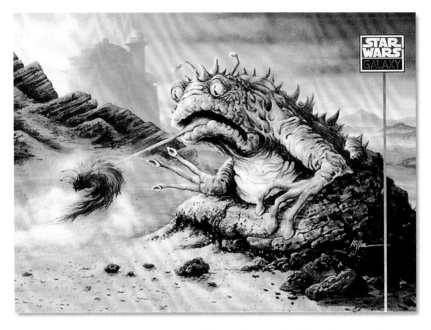

Fully painted in all his grotesque glory was the toad-like worrt from outside Jabba's palace, captured in tongue-catch mode by **David O. Miller**.

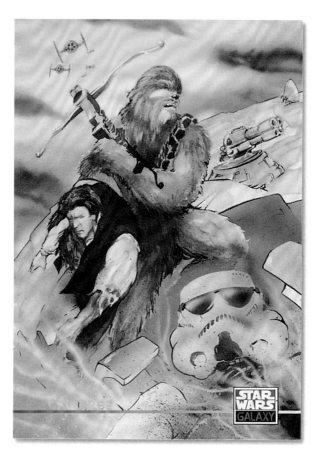

Chewbacca repays Han Solo for rescuing him from Imperial slavery in this action-packed painting by **C. Scott Morse**.

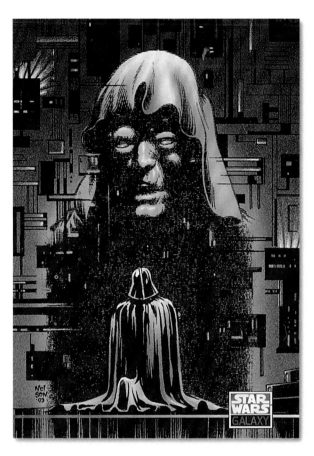

Mark Nelson rendered this atmospheric Darth Vader/Emperor Palpatine scene from *The Empire Strikes Back*, with color provided by **Richard Ory**.

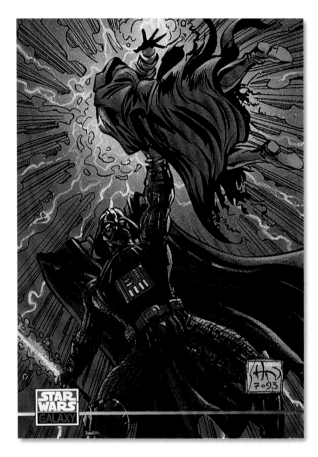

Darth Vader finally sees the light and turns against his power-mad emperor, as rendered by **Hoang Nguyen**, with color by **Richard Ory**.

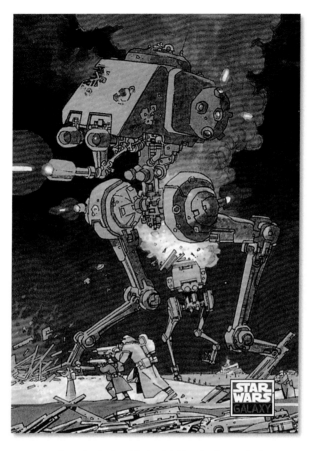

Kevin O'Neill inked and colored this battlefield study of Imperial "chicken walkers" on the rampage.

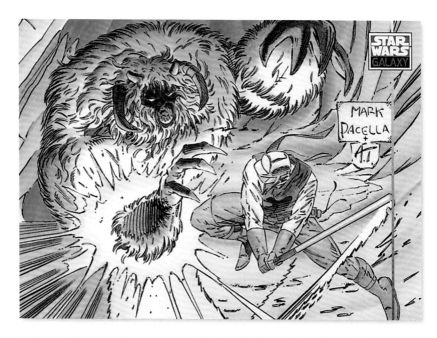

Luke's battle with the flesh-hungry wampa on Hoth inspired this **Mark Pacella** rendering, which was inked by **Art Thibirt** with color by **John Cebollero**.

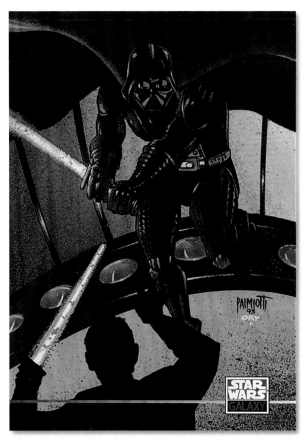

Jimmy Palmiotti provided this exciting depiction of Darth Vader dueling with Luke in *The Empire Strikes Back*. Color by **Richard Ory**.

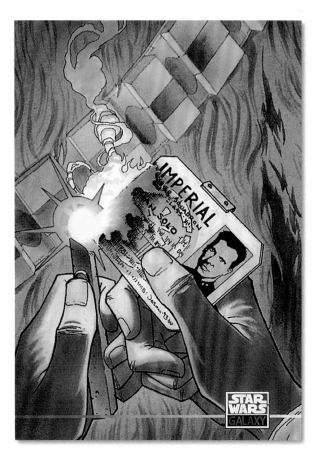

Han, after rescuing Chewie from slavery, burns his Imperial draft card in this imaginative rendering by **Jason Pearson**, with color by **Mike McPhillips**.

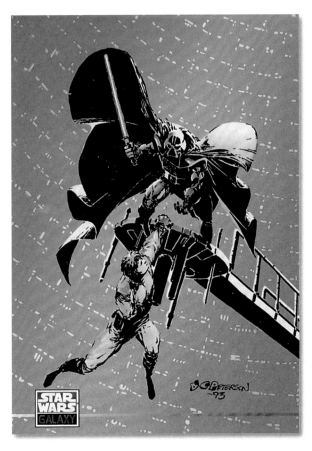

Brandon Peterson captured this moment of supreme decision, as Luke resists the dark call of his true father. Color by **Mike McPhillips**.

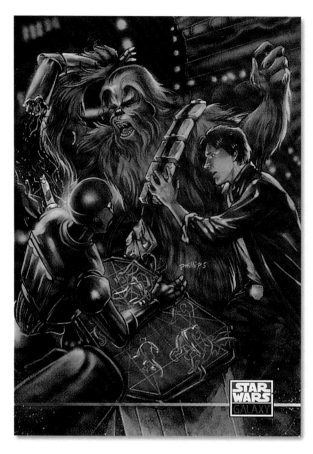

Painter **Joe Phillips** had fun depicting an imaginary outburst from Chewbacca during a holochess game, the result of his adversary's unwise move.

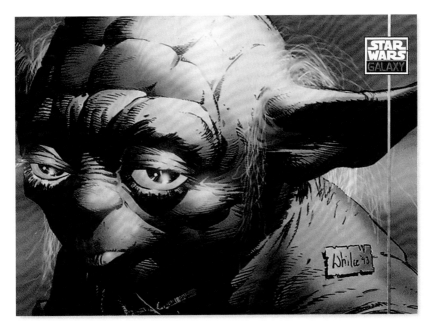

Focusing on Yoda's soulful eyes, **Whilce Portacio** penciled, inked, and colored this remarkable close-up of the Jedi master.

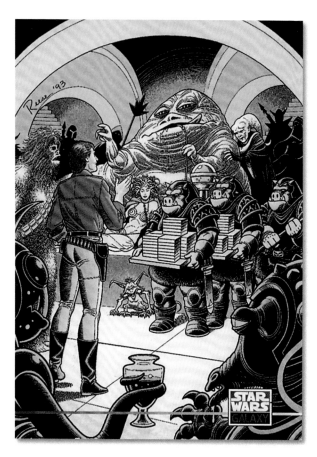

Han Solo smooth-talks his way into a big loan from Jabba the Hutt in this fanciful illustration drawn, inked, and colored by **Ralph Reese**.

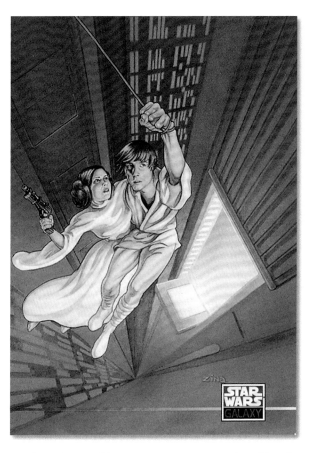

In her heroic depiction of this iconic event, painter **Zina Saunders** celebrated Luke and Leia's famous swing to safety in the original movie.

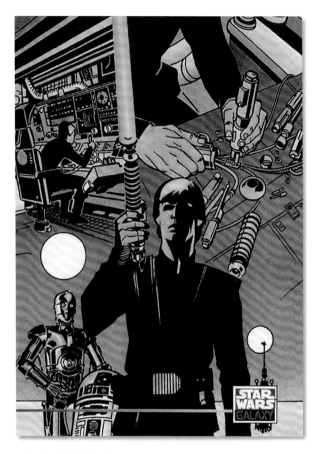

Luke Skywalker fashions his second lightsaber in this inked montage courtesy of **Chris Sprouse**, with color by **John Cebollero**.

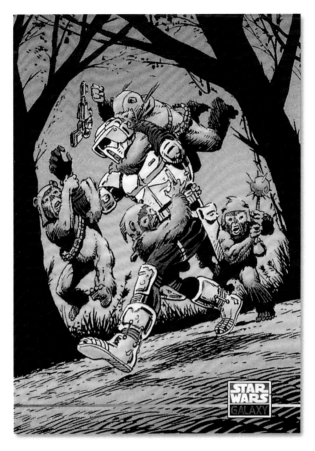

Illustrator **Jim Starlin** saw the whimsical side of a biker scout's Ewok dilemma but never abandoned suspense and drama completely.

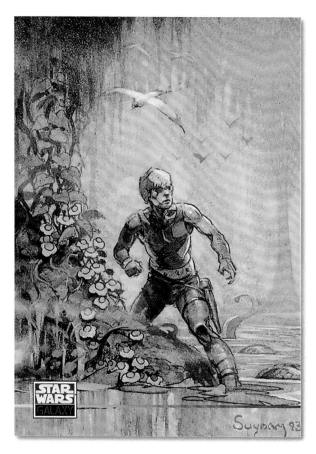

Arthur Suydam provided the strong lines and semipastoral color scheme for this study of Luke Skywalker on the swamp world Dagobah.

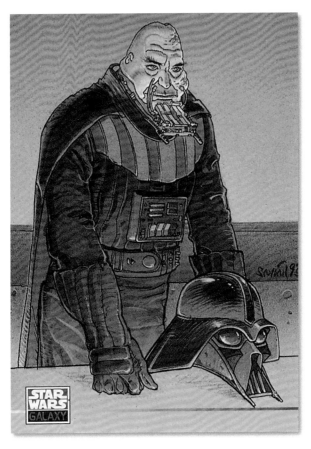

Darth Vader was unmasked by illustrator **Sylvain** in this inked-and-colored rendering that explores the triumph of man over machine.

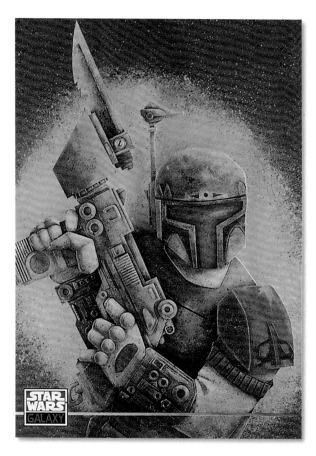

Tom Taggart used a unique, three-dimensional coloring approach to bring armed-and-merciless Boba Fett to illustrated life.

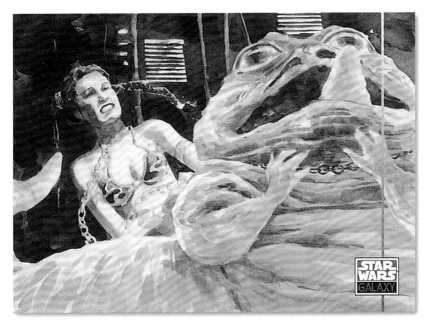

A rightfully pissed-off Leia strangles the life out of bloated captor Jabba the Hutt in this watercolor rendering by **Jill Thompson**.

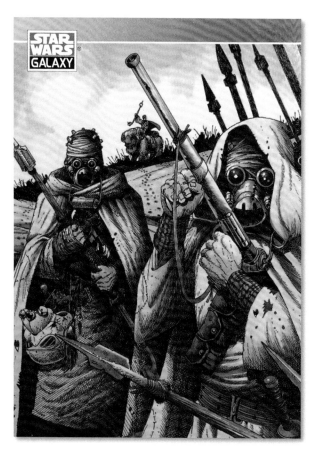

Illustrator and *Star Wars* fan **Tim Truman** enjoyed depicting Tatooine's dusty and dangerous Tusken Raiders (also known as Sand People).

Keith Tucker penciled and inked this formidable, insect-like droid that appeared on the original Death Star. Color by **John Cebollero**.

Admiral Ackbar was so admirable a character that **Jeff Watts** couldn't resist painting this tribute to him, complete with an exciting starfighter battle.

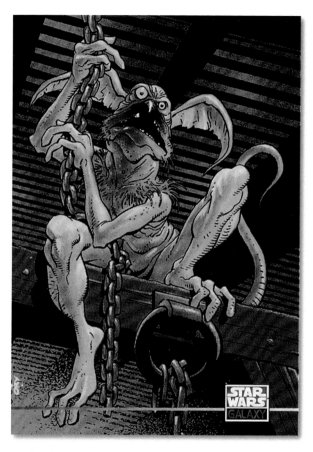

Penciler/inker **Mike Zeck** chose to depict Salacious B. Crumb under attack, capturing the indignant little villain's sense of outrage. Color by **Richard Ory**.

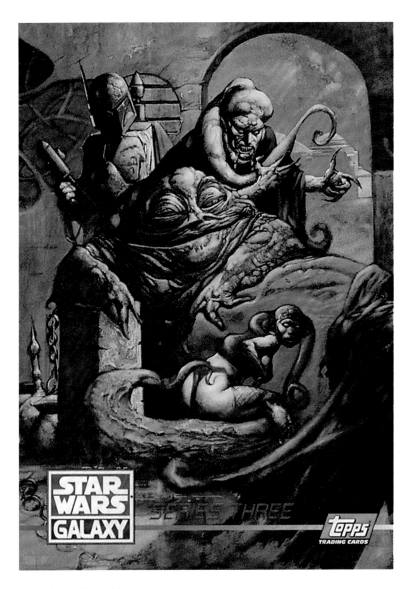

Title card, art by **Simon Bisley**.

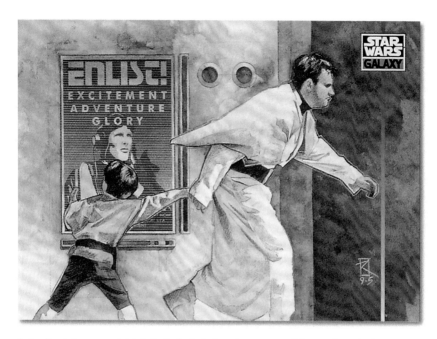

Rather than being arranged alphabetically, the Series 3 cards were arranged thematically. In this first group, **Russell Walks** used his watercolor skills to illustrate the nine-card subset entitled "From Camelot to Tatooine," which explores the cultural philosophy of Joseph Campbell and how it influenced George Lucas's *Star Wars* saga. Russ even supplied the text on the back of the cards.

"The Call to Adventure" depicts a young Luke being dragged away from an Imperial enlistment poster by ever-concerned Uncle Owen Lars.

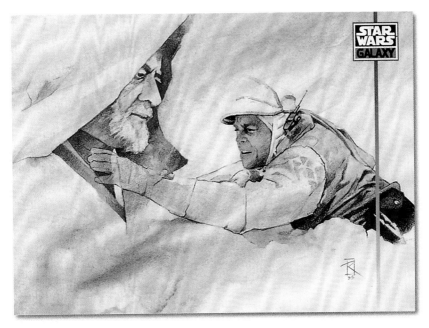

"Supernatural Aid" revisits Luke's metaphysical encounter with Obi-Wan Kenobi on snow-blasted planet Hoth.

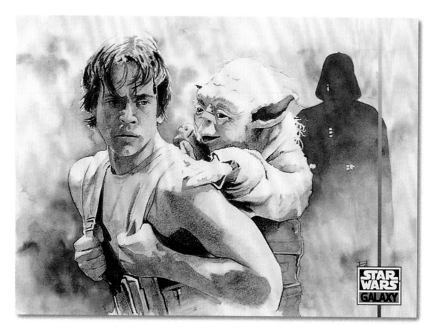

"The Road of Trials" explores Luke's brush with his own potential "dark side" while in training as a Jedi on Dagobah.

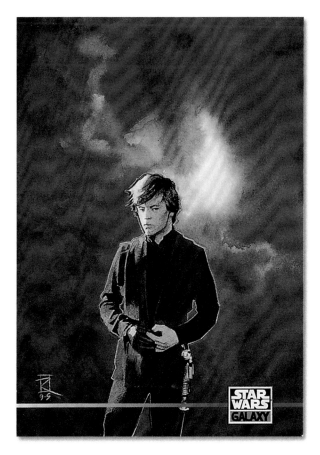

"The Ultimate Boon" here represents young Skywalker's triumph over the forces of darkness as well as his father's dramatic redemption, which brings events full circle.

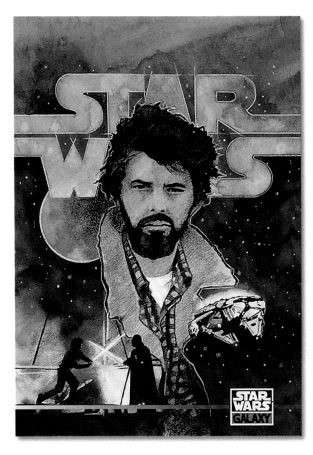

"Joseph Campbell/George Lucas" deals with the young director's creative and philosophical inspiration for creating *Star Wars*.

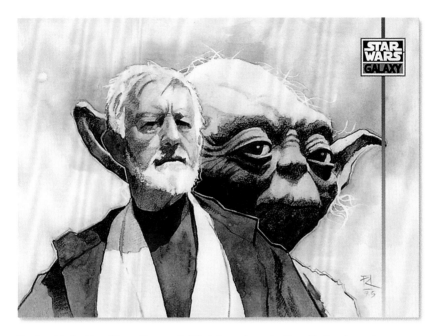

"The Force" looks at how this mystic energy field fuels the passion and actions of Jedi masters such as Obi-Wan Kenobi and Yoda.

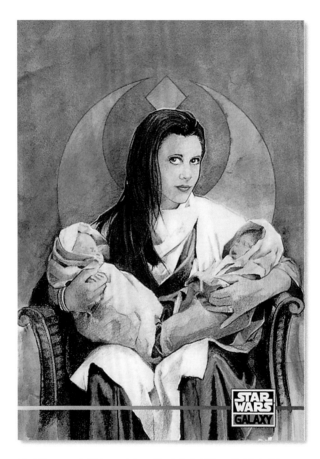

Depicting a married Princess Leia and her infant children, "Leia" depicts how this determined freedom fighter finds personal happiness and inner fulfillment.

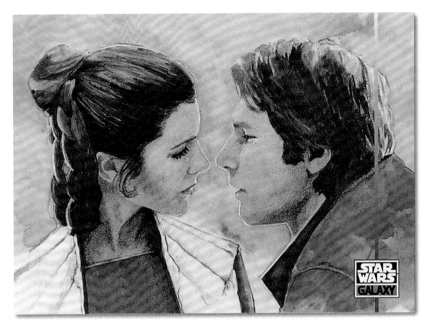

"Han Solo" tracks the young Corellian's transformation from self-centered mercenary to freedom-loving hero and proud family man.

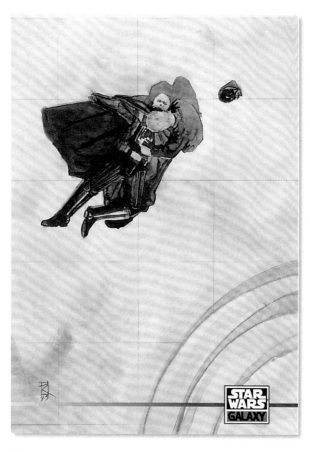

"Skywalker/Vader" recalls the final, heartfelt moments between father and son as Palpatine's vanquished Empire crumbles around them.

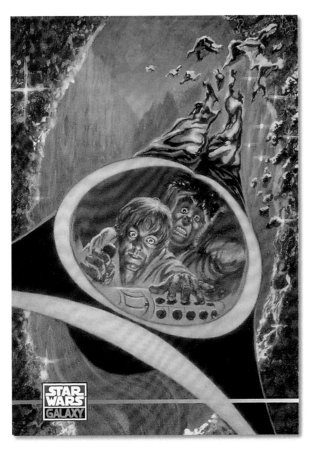

For the first card in the "Alternate Visions" subset, *MAD* Magazine artist **Frank Kelly Freas**, who became NASA's official mission artist, rendered this fanciful view of Luke zipping through Beggar's Canyon on Tatooine.

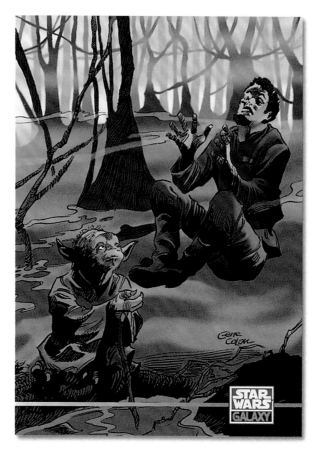

An unnamed would-be Jedi is trained to levitate by Master Yoda in this speculative pen-and-ink illustration by comics industry veteran **Gene Colan**.

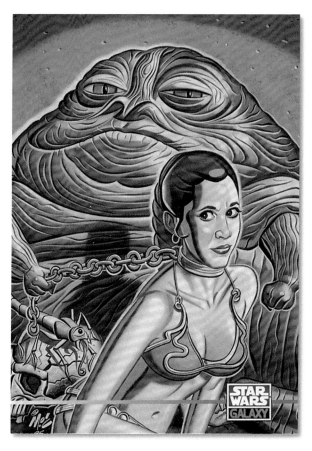

Mitch O'Connell captured Leia's patient demeanor as she waits for an opportunity to pay back Jabba the Hutt for enslaving her.

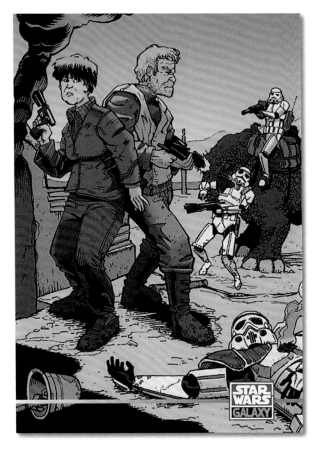

Uncle Owen and Aunt Beru go down fighting as stormtroopers attack their Tatooine homestead in this heroic interpretation by **Mike Avon Oeming**.

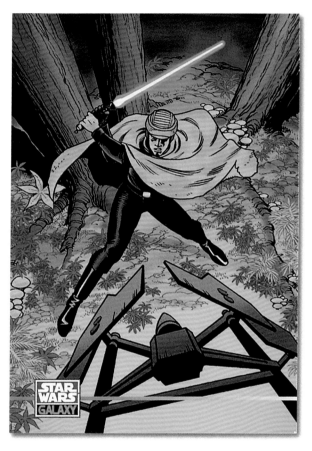

Tim Eldred provided this exciting image from the point of view of an Imperial biker scout that focuses on Luke Skywalker's deft retaliation with his lightsaber.

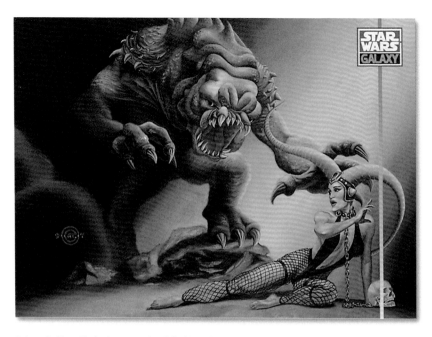

Painter **Cathleen Thole** always wondered if Jabba's slave girl Oola was actually eaten by the rancor, so she chose to depict this moment of truth, while still leaving the question open.

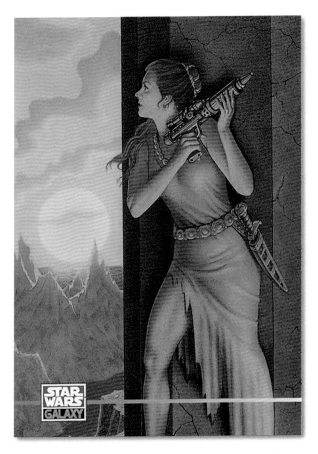

A blaster-packing Princess Leia is ready to take on all threats in this sunlit painting by **Don Punchatz**.

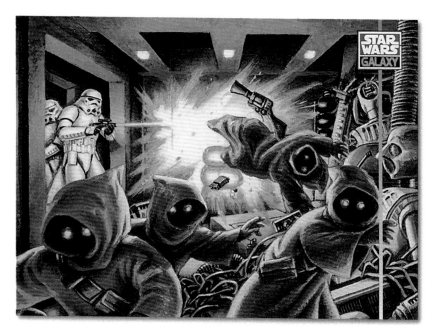

Cartoonist **John Pound** (of *Garbage Pail Kids* fame) rendered this massacre of a band of unlucky Jawas by Imperial stormtroopers during their search for C-3PO and R2-D2.

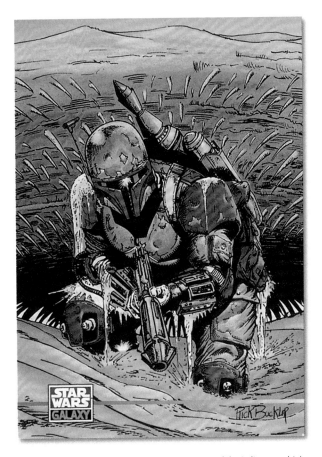

Recalling Boba Fett's near-fatal engulfment in *Return of the Jedi*, pen-and-ink artist **Rick Buckler** depicted the apparently indigestible bounty hunter in the sarlaac pit.

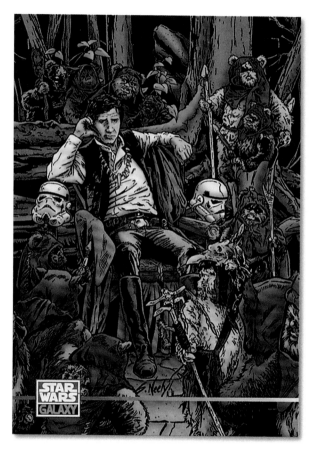

Scott Neely rendered this amusing study of Han Solo on the forest moon of Endor, surrounded by Ewok allies.

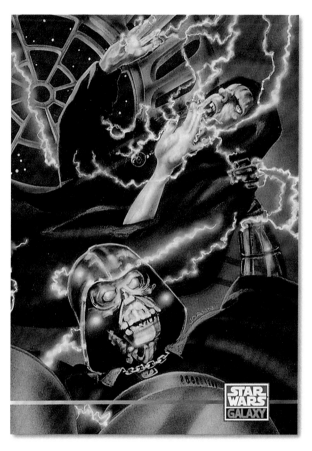

Illustrator **Joann Daley** nailed this high point from *Return of the Jedi*, as a redeemed Darth Vader turns on his evil master.

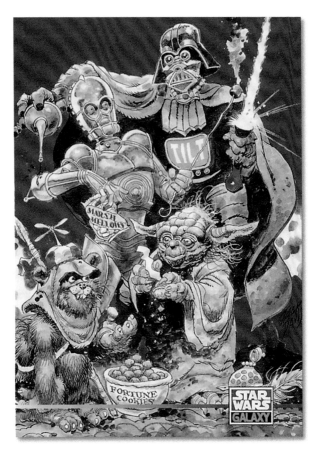

It was all fun and games and tongue-in-cheek satire when famed *MAD* Magazine artist **Jack Davis** turned his attention to *Star Wars*.

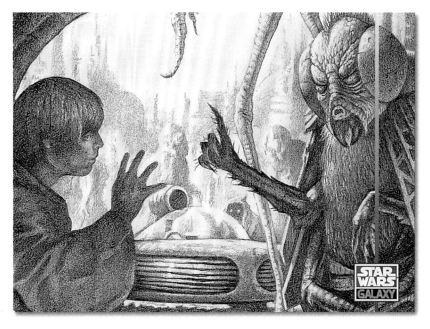

A specialist in black-and-white pencil work, **Mark "Crash" McCreery** had fun imagining Luke's selling of his landspeeder, as mentioned but not shown in the original *Star Wars*.

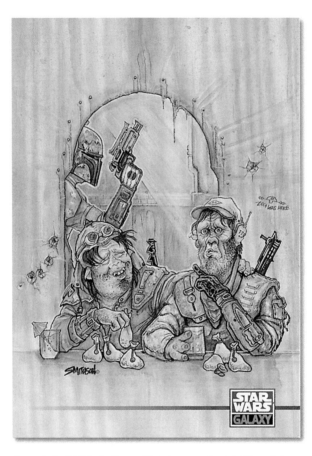

Conceptual artist **Mike Smithson** added a humorous touch to this rendering of Boba Fett and some luckless bounty-hunter competitors.

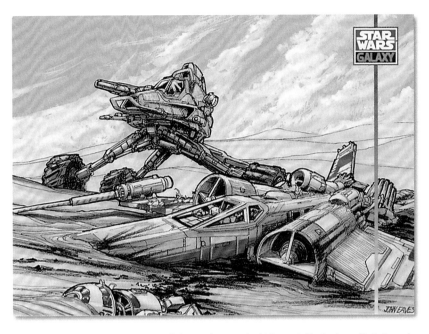

Pictured alongside Luke's downed X-wing fighter is a large-tired vehicle, created by hardware illustrator and sci-fi specialist **John Eaves**.

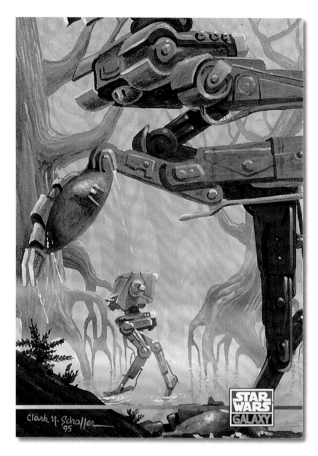

Clark Schaffer—Hollywood special-effects designer, matte painter, and book illustrator—envisioned Imperial "chicken" walkers (AT-STs) in a swampy milieu.

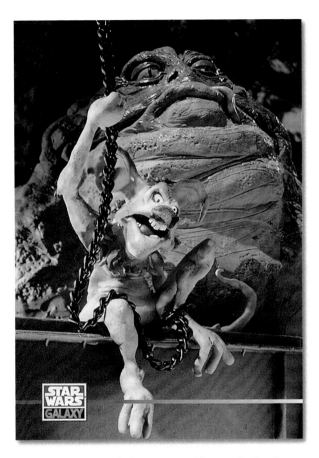

Salacious B. Crumb and Jabba the Hutt were joyfully painted by **Gary S. Bialke** of Will Vinton Studios, a company that specialized in claymation projects.

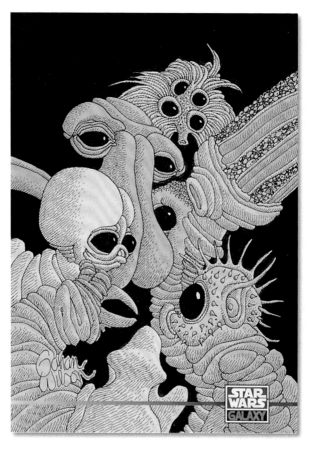

This offbeat gaggle of cantina creatures was rendered by famed cartoonist/illustrator **Gahan Wilson**.

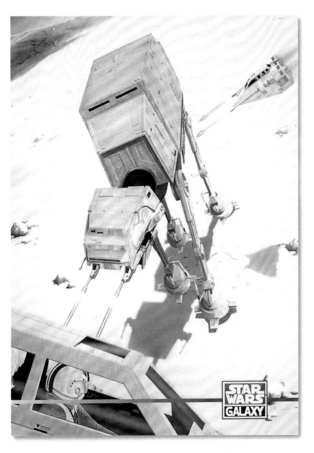

The first card in *"The Empire Strikes Back"* subset, provided by toy designer/illustrator **Steven R. Reiss**, is a rendering of AT-ATs on the rampage, as inspired by his favorite scene from *The Empire Strikes Back*.

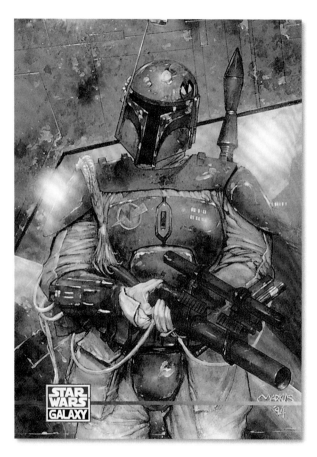

It's badass bounty hunter Boba Fett, *Empire*'s semisilent new villain, rendered in all his formidable glory by visual artist **Mark Harrison**.

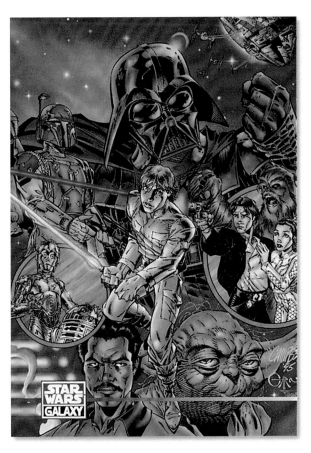

J. Scott Campbell (pencils) and **Alex Garner** (inks) collaborated on this thrilling montage that also appeared on the cover of Topps's *Star Wars Galaxy Magazine* issue number 1 in fall 1994.

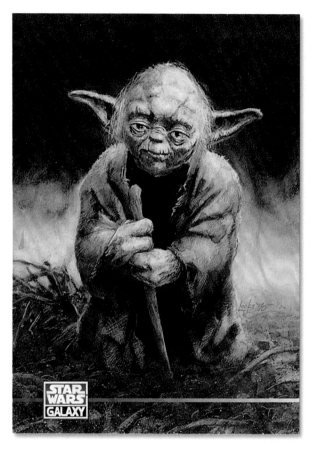

Illustrator **Vince Locke** painted this portrait of Jedi master Yoda on Dagobah, about to help young Luke Skywalker with his training.

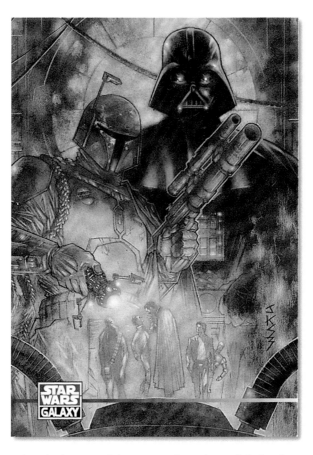

Vader and Boba Fett use a holoprojector to observe the arrival of Solo and his friends on Cloud City in this scene imagined by comics artist **John K. Snyder III**.

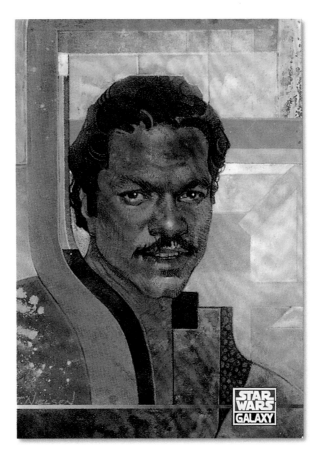

Terese Neilsen painted this wonderful portrait of Lando Calrissian, which also appeared in issue number 4 of *Star Wars Galaxy Magazine* (Summer 1995).

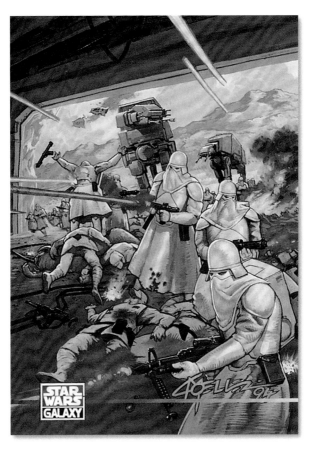

Imperials, aided by AT-ATs, win the day on Hoth in this rendering by
Christopher Moeller, which also appeared in issue number 6 of *Star Wars
Galaxy Magazine* (Winter 1996).

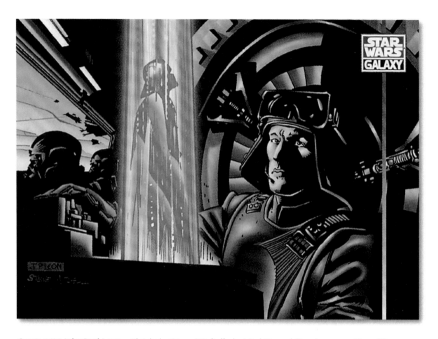

Comic artist **John Paul Leon**, with inks by **Steve Mitchell**, depicted General Veers's conversation with a holographic Darth Vader.

A chase card set was created for our *Star Wars Galaxy* Series 3 called "Agents of the Empire," which was printed in the Clear Zone format (an illustration on transparent colored plastic). In this exciting scene rendered by Image Comics artist **Brett Booth** (who is perhaps best known for WildStorm's *Backlash*), bounty hunter Boba Fett squares off against his perennial foes, Han Solo and Chewbacca.

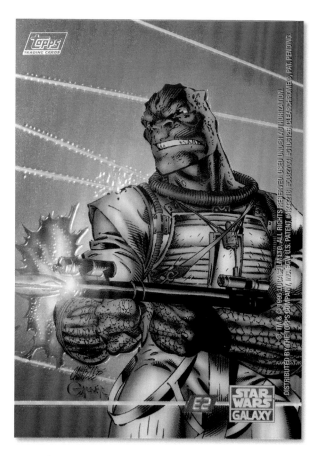

Topps's Clear Zone chase cards for *Star Wars Galaxy* Series 3 were dedicated to the infamous bounty hunters first introduced in *The Empire Strikes Back*. This depiction of reptilian tracker Bossk, one of several ruthless agents of the Empire, was handled by Image Comics artist **J. Scott Campbell**, who has impressed fans over the years with his creations for WildStorm, Marvel, and the video game industry.

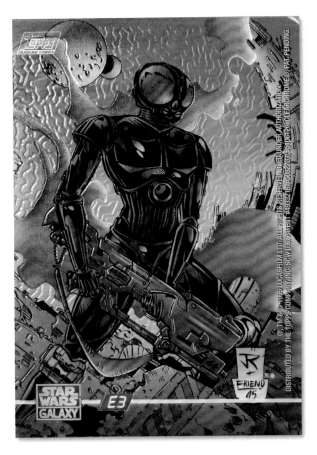

The third bounty hunter destined for our Clear Zone chase cards was 4-LOM, played in *The Empire Strikes Back* by Chris Parsons. His name was something of an "in" joke . . . "for love of money." Image Comics artist **Jeff Rebner** rendered this renegade protocol droid, who ambitiously overwrote his own programming to embark on a life of crime. Rebner worked with WildStorm on *Cybernary* and *Wetworks* and with Marvel on *The Incredible Hulk*.

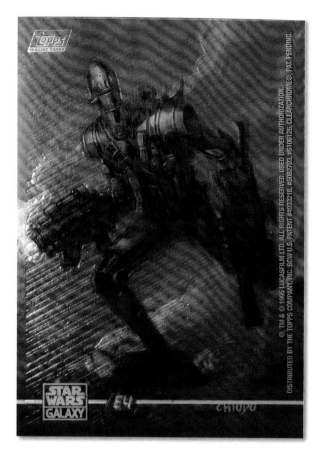

Arguably the strangest bounty hunter of the motley crew assembled by Darth
Vader in *The Empire Strikes Back* was towering, treacherous IG-88. A state-
of-the-art assassin droid, he was designed with an incomplete identity, which
might account for his killing obsession. This IG-88 portrait was rendered by
Image Comics artist **Joe Chiodo**, whose style deftly combines cartooning
with pin-up flamboyance.

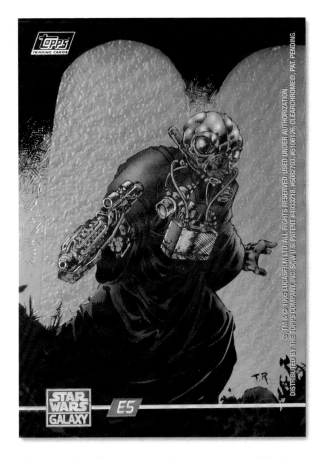

STAR WARS GALAXY

E5

Often referred to as "The Uncanny One," Zuckus was a successful Gand bounty hunter frequently partnered with the droid 4-LOM. Noted comic book artist **Tom Raney**, who rendered this nefarious tracker, started his career at DC Comics. Raney went on to illustrate *Alpha Flight* and *Uncanny X-Men* for Marvel, and *DV8* and *Stormwatch* for Image Comics.

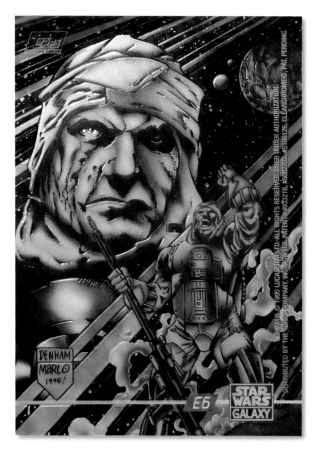

Corellian bounty hunter Dengar was rebuilt by the Empire as a master assassin, augmented by various neuro-implants and enhancements. He's seen here in all his unsavory glory, as rendered by Image Comics artist and former marine, **Brian Denham**. Benham's celebrated work includes the *X-Files* comic book (during his WildStorm period), and, from 2015, an adaptation of *Knight Rider* for IDW.

OPPOSITE: SERIES 2 PROMO CARD FEATURING LUKE SKYWALKER (MARK HAMILL).

The most popular trading card set of 1993 is now the main event of 1994

INTRODUCING

SERIES TWO
DELUXE TRADING CARDS
FROM

ALL NEW CARDS
ALL NEW VISIONS
ALL NEW ARTISTS

135 full color deluxe quality cards featuring newly created artwork by more than 75 of the brightest names in comics and science fiction.

SHIPPING SPRING 1994

BONUS: SIX ALL NEW ETCHED FOIL CHASE CARDS

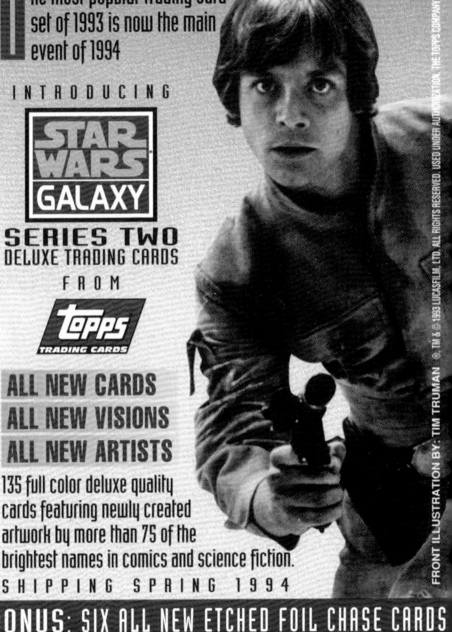

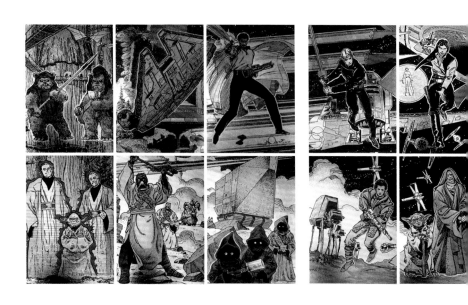

Walter Simonson rendered three exciting montages comprised of eighteen puzzle pieces (with color by **Arthur Suydam**). These foil chase cards were presented in Series 1 (middle), 2 (right), and 3 (left). All three sets of illustrations fit together to form a unique triple vista.

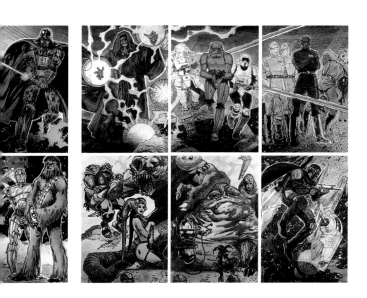

"A Tribute to George Lucas," *Star Wars Galaxy* Series 1, card no. 2, 1993.

AN INVITATION TO THOUGHTFUL MEDITATION
BY DREW STRUZAN

I suppose I am writing this because it has been my blessing to illustrate the movie posters for *Star Wars* since the first one, in 1977. That's nearly forty years' worth of images, shared by parents, children, and grandchildren. I was there at the beginning. We are seven tales into the saga now, and I've had the delight to paint them all. It is a great honor that my artwork is seen throughout the world. Art without an audience is lifeless, but an artist with an audience is happy and at his or her best. I'm happy for all the artists found in this collection, and I'm happy that you have picked up this volume, as your attention gives us purpose.

Star Wars Galaxy brings us a new wave of creative talent. Some of these images you may have seen when they were first created as trading cards by Topps in 1993, and some you may have missed. As I thumbed through the plenitude of imaginative choices, I became absorbed in the bounty I was holding in my hands. But what to say about it all eluded me, because, as an artist, I create images with my hands rather than in words. I explore with my eyes and translate my feelings into pictures. An image is often open-ended. It addresses the artist's experiences, hopes, and desires. What can I say about other artists, who,

like me, contribute visually to the world around them? Their artwork touches the heart and influences the mind. It makes spirits soar. And that's the point, is it not?

Star Wars is an enigma in and of itself. It entered our lives and consciousness four decades ago and has spread from generation to generation. It helped us reframe classic tales into a modern context. It opened our minds to dream new dreams and embrace an entire new world. Is it any wonder that so many artists have chosen to express themselves in this universe?

As you thumb through this book, I'm sure you'll find it interesting. But it is far more than that. It is truly something special. *Star Wars* is the glue that holds it together, the world that inspired these many gifts, but the gifts must be unwrapped to be appreciated. This volume is a handful of love and beauty and wisdom as expressed by each distinct creator. Every piece is a true expression of the heart and soul of the individual artist. As you explore the images on these pages, I hope you pause to enjoy more than the sheer diversity of styles. Open your hearts and minds to a journey of artistic discovery.

I suggest that you take this book down from its shelf daily. Relax in a quiet place for a few minutes. Open to the first

illustration, and begin to live with it. Start by just looking. No preconceived thoughts. Look with your heart. Trust me, it will speak to you in ways you may not have imagined, perhaps awakening a force within you. If you are a Padawan, this might be the first step of training with a Jedi knight or master. Don't be concerned. We all begin at the beginning. When I was a child, I dreamed of creating the best piece of art the world has ever seen. As I grew, I realized that, as this book amply demonstrates, there is no one best way to anything or anywhere. There are, in fact, many paths to beauty, and a creative soul wanders among them all.

Want more than the basics?

Try to analyze what it is that the artist has done in the picture that makes you feel the way you do. Is it the choice of subject matter? The character? The setting? How about the choice of theme or the composition? Try to understand why you like it . . . or why you don't. Are you at peace with the image, or angry or ambivalent? Have you found a friend or an enemy? Have you found encouragement, hope, truth, beauty, or love?

All these gifts and more are waiting for you within these pages—more than two hundred gifts of art to experience. These are gifts to you, from the heart of each artist to yours. Consider this an invitation to thoughtful meditation. You'll be wiser, deeper, and more grateful for all the joy you experience contemplating art for a few minutes each day.

My promise: *Star Wars Galaxy* will help you be greater than you think you are and as great as you can be.

DREW STRUZAN
CALIFORNIA
AUGUST 2015

DREW STRUZAN's award-winning art is some of the most iconic in modern cinema. He has more than 150 movie posters to his credit, including every *Star Wars* and *Indiana Jones* film, as well as the *Back to the Future* trilogy, *Blade Runner*, *E.T. the Extra-Terrestrial*, *The Muppet Movie*, and *Harry Potter and the Sorcerer's Stone*. Struzan has been called "my favorite movie artist" by Steven Spielberg and "one of the very best" by George Lucas, who considers him "the only collectible artist since World War II." According to film critic and historian Leonard Maltin, "Struzan created some of the most indelible images of our time." He is the subject of three monographs, *The Movie Posters of Drew Struzan* (2004), *The Art of Drew Struzan* (2010), and *Drew Struzan: Oeuvre* (2011), as well as the documentary *Drew: The Man Behind the Poster* (2013). Struzan lives in California.

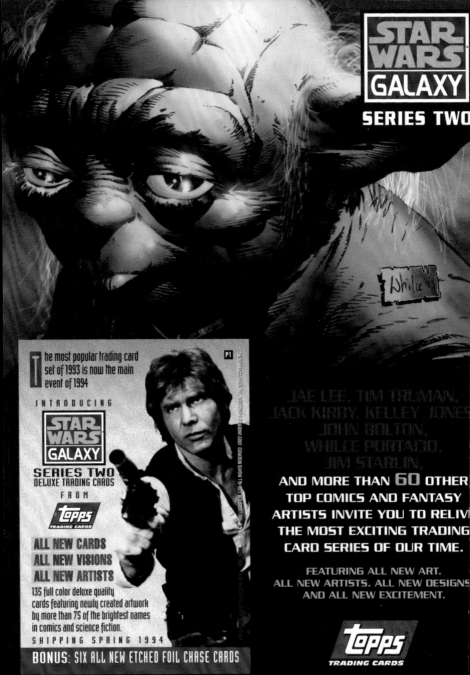

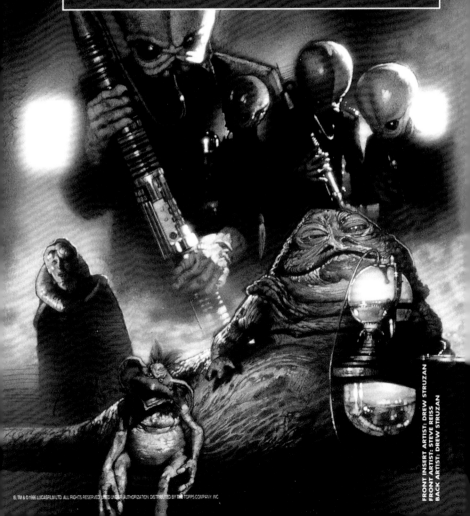

EXPLORE A BRAND NEW GALAXY

A New Direction for the most critically acclaimed series of our time.

- **BRAND NEW ART** • **BRAND NEW ARTISTS** • **12 SPECIAL FOIL INSERTS**

- **SIX NEW ETCHED FOIL CHASE CARDS BY WALT SIMONSON, COMPLETING THE 18 CARD *STAR WARS* GALAXY PANORAMA**

- **SUPER BONUS: SIX CLEAR CHROMIUM "AGENTS OF THE EMPIRE" CHASE CARDS FEATURING THE FEARSOME BOUNTY HUNTERS FROM *THE EMPIRE STRIKES BACK.***

- **PLUS: 1ST DAY ISSUE CARD IN EVERY PACK!**

COMING FALL 1995

FRONT INSERT ARTIST: DREW STRUZAN
FRONT ARTIST: STEVE REISS
BACK ARTIST: DREW STRUZAN

ABOUT THE ARTISTS

MICHAEL ALLRED is a comic book artist and writer best known as the creator of *Madman*.

KARL ALTSTAETTER is a writer, penciller, inker, and editor who worked for Image, Marvel, and DC Comics before forming his own company, Hyperwerks Comics.

THOM ANG is a penciller and inker who is the former lead artist for Disney Interactive and has worked for such companies as Random House, DC Comics, and Marvel Comics.

SERGIO ARAGONÉS is a cartoonist and writer known for his contributions to *MAD* Magazine. He is also the creator of the comic book *Groo the Wanderer*.

MARSHALL ARISMAN is an iconic artist whose work is featured in many museums, including the Metropolitan Museum of Art, Smithsonian Institution, and Telfair Museums. His illustrations and editorial work have appeared in a number of national publications, including *Time*, *Rolling Stone*, and *Esquire*.

KYLE BAKER, cartoonist, comic book writer-artist, and animator, is the creator of multiple award-winning graphic novels, including *Why I Hate Saturn* and *Nat Turner,* as well as the acclaimed miniseries *Truth: Red, White & Black*.

DAN BARRY is a cartoonist who revived the *Flash Gordon* daily newspaper strip and wrote and illustrated many Indiana Jones and Predator comics.

GARY S. BIALKE was an airbrush artist and Claymation sculptor who worked at Will Vinton Studios.

SIMON BISLEY is an award-winning British comics artist whose work includes *ABC Warriors*, *Lobo*, *Sláine*, *Judge Dredd*, and *Heavy Metal*.

BRET BLEVINS is a comic book artist, animation storyboard artist, and painter best known for *New Mutants*.

JOHN BOLTON is a comic book artist who specializes in horror. His dense, painted style often verges on photorealism.

TED BOONTHANAKIT is a storyboard artist who has worked on movies such as *The Hangover*, *Spider-Man 2*, and *Up in the Air*.

BRETT BOOTH is a comic book artist and co-creator of the character Backlash. Booth's illustrations have also appeared in *Spider-Man*, *Fantastic Four*, and *X-Men*.

TIMOTHY BRADSTREET's illustrations have appeared on comics, book covers, movie posters, role-playing games, and trading cards.

DAN BRERETON is an award-winning comic book writer and illustrator. He has worked on Batman, Superman, and JLA for DC Comics, as well as projects for Bongo Comics, Boom! Studios, Dark Horse, Disney, Dynamite, Marvel, and Oni Press. He is also the creator of *The Nocturnals*.

JUNE BRIGMAN is a comic book artist and co-creator of the *Power Pack* series. She was also the artist of the syndicated newspaper strip *Brenda Starr*.

RON BROWN is an award-winning sci-fi and fantasy illustrator.

FRANK BRUNNER is a comic book artist and illustrator whose work for Marvel Comics includes *Doctor Strange*, *Howard the Duck*, and *Giant-Size Man-Thing*.

RICH BUCKLER has drawn just about every character for DC Comics and Marvel. He is the creator of Deathlok and was the illustrator for an acclaimed run on *The Fantastic Four* for Marvel Comics in the mid-1970s.

RICK BUCKLER is a comic book artist who began his career at Continuity Comics. He is the son of artist Rich Buckler.

J. SCOTT CAMPELL is a comic book artist whose work has appeared on the covers of *The Amazing Spider-Man*.

GREG CAPULLO is a comic book artist and penciller whose work includes *Quasar*, *X-Force*, *Angela*, *Spawn*, and *Batman*.

JOHN CEBOLLERO is a colorist, inker, and illustrator who has worked for many companies, including DC Comics, Milestone, and Marvel.

PAUL CHADWICK is a comic book creator known for his award-winning series *Concrete*.

HOWARD CHAYKIN illustrated the first ten issues of the Marvel *Star Wars* comic book series and is the creator of the *American Flagg!* series.

MARK CHIARELLO is a painter, comic book editor, and vice president of art direction and design at DC Comics. He is the artist of *Heroes of the Negro Leagues* and comics such as *Batman & Houdini*, *Hellboy*, and *Hellraiser*.

JOE CHIODO is an award-winning comic book artist and colorist who has worked with every major comic book publisher.

GENE COLAN was a comic book artist best known for his work for Marvel Comics, including acclaimed runs on *Daredevil*, *Howard the Duck*, and *The Tomb of Dracula*. Colan was inducted into the Will Eisner Comic Book Hall of Fame in 2005.

AMANDA CONNER is a graduate of the Joe Kubert School of Cartoon and Graphic Art. Her work includes *Power Girl*, *Vampirella*, and illustrations for the *New York Times*.

JOANN DALEY is an advertising and movie poster artist for Hollywood.

GEOF DARROW is an award-winning artist whose comic book work includes *Hard Boiled*, *Big Guy and Rusty the Boy Robot*, and *Shaolin Cowboy*.

DEBBIE DAVID worked extensively for DC Comics and Defiant Comics in their production departments. She is the penciller, inker, and colorist of the comic book series *Panorama*.

JACK DAVIS is a cartoonist and illustrator whose iconic images appeared for over five decades in *MAD* Magazine. He is also a beloved advertising artist whose award-winning illustrations have graced the covers of countless magazine covers, movie posters, and record albums.

RICARDO DELGADO is a film and comic book artist who created the *Age of Reptiles* comic book series and has worked on such films as *The Incredibles*, *Men in Black*, and *Apollo 13*.

BRIAN DENHAM is an artist and former marine who has worked for Marvel, DC Comics, WildStorm, and many other comic book publishers.

JOE DEVITO is an award-winning fantasy artist and sculptor of many of pop culture's most recognizable icons, including King Kong, Doc Savage, Tarzan, Alfred E. Neuman, Superman, Batman, Wonder Woman, Lobo, and Spider-Man. He is also the author of *Kong: King of Skull Island*.

STEVE DITKO is a reclusive comic book legend who has worked for Marvel, Charlton, and DC Comics. He has created and co-created a number of seminal comic book characters including Spider-Man; Doctor Strange; Blue Beetle; the Question; the Creeper; Shade, the Changing Man; Hawk and Dove; and Mister A.

COLLEEN DORAN is a writer and cartoonist whose work includes *The Sandman, Wonder Woman,* and *Legion of Super-Heroes*.

DAVE DORMAN is a sci-fi, horror, and fantasy illustrator known for his *Star Wars* artwork.

LES DORSCHEID is a comic book artist who has worked for DC, Marvel, and Dark Horse Comics.

NORM DWYER is a comic book and 3D computer artist who has worked for Marvel and DC Comics.

JOHN EAVES is a concept illustrator and designer known for his work on the series *Star Trek: The Next Generation*.

TIM ELDRED is a comic book artist and creator of the *Grease Monkeys* and the *Star Blazers* series.

GEORGE EVANS was a cartoonist and illustrator whose seminal work in comic books, magazines, and comic strips included the shocking E. C. Comics cover for *Crime Suspenstories* no. 23, which was held up as evidence at the infamous comic book hearings conducted by the U.S. Senate Subcommittee on Juvenile Delinquency in 1954.

STEVE FASTNER is an acclaimed airbrush artist who works with Rich Larson as part of the comics and fantasy art team, Fastner & Larson. Their work includes portfolios of the Hulk, X-Men, and Spider-Man.

BOB FINGERMAN is a comic book writer and artist best known for his indie comics series *Minimum Wage*.

HUGH FLEMING is a writer and artist who has contributed to *Star Trek*, *Batman*, and the *Green Arrow/Green Lantern* series.

FRANCHESCO is the co-creator of Adam in DC's Green Lantern Corps, and illustrator of *Scavengers* for Triumphant.

FRANK KELLY FREAS, a science fiction and fantasy artist known as the Dean of Science Fiction Artists, was inducted into the Science Fiction Hall of Fame. His most famous work appeared on the record album cover of Queen's *News of the World*, as well as on more than thirty magazine covers for *MAD* in the 1950s and early 1960s.

DREW FRIEDMAN is an award-winning cartoonist, illustrator, and famed caricaturist whose work appears regularly in *MAD* Magazine, *Entertainment Weekly*, *Newsweek*, *Time*, the *New York Times*, the *Wall Street Journal*, and the *New Yorker.* His books include *Old Jewish Comedians* and *Heroes of the Comics.*

ALEX GARNER worked as an artist on *Gen 13* and *Danger Girl.* Garner and three partners formed IDW Publishing in 1999, and he has been the creative director and lead artist of several service projects for companies such as Upper Deck, Bandai, Marvel, and DC Comics.

RICK GEARY is an award-winning cartoonist and illustrator with a distinctive art style who has contributed to *Heavy Metal* and *National Lampoon*. He has also created a variety of comic books and graphic novels for numerous publishers.

DAVE GIBBONS is a seminal artist and writer whose collaborations with Alan Moore include *Watchmen* (generally considered by critics and fans to be the greatest comic book series and graphic novel).

KEITH GIFFEN is a comic book illustrator and writer who has worked on the *Legion of Super-Heroes*, *Heckler*, *Nick Fury's Howling Commandos*, *Reign of the Zodiac*, *Suicide Squad*, *Metal Men*, and *T.H.U.N.D.E.R. Agents*, among other titles.

JEAN "MOEBIUS" GIRAUD was a world-renowned artist, cartoonist, and writer known for his conceptual work on such sci-fi films as *Alien*, *Tron*, *The Fifth Element*, and *The Abyss*.

MIKE GRELL is a comic book writer and artist whose work includes *Green Lantern/Green Arrow,* *The Warlord,* and the *Jon Sable Freelance* series.

REBECCA GUAY is an artist whose commissions include role-playing games, collectible card games, and comic books.

PAUL GULACY is the illustrator of *Sabre: Slow Fade of an Endangered Species* (written by Don McGregor and published by Eclipse Comics in 1978), one of the first modern graphic novels.

LURENE HAINES has worked on *Green Arrow: The Longbow Hunters* for DC Comics and *Hellraiser* for Epic.

MATT HALEY is a film and art director as well as an illustrator. His notable comic book works include *Ghost* (Dark Horse Comics) and *Elseworld's Finest: Supergirl and Batgirl* (DC Comics).

CULLY HAMNER is a comic book artist and writer known for his work on *Green Lantern: Mosaic*, *Blue Beetle*, *Black Lightning: Year One*, and *Detective Comics*.

BO HAMPTON is a comic book artist and cartoonist known for *Viking Glory*, *Legend of Sleepy Hollow*, and *Verdilak*.

SCOTT HAMPTON is a comic book artist who has illustrated such iconic properties as *Batman*, *Sandman*, *Black Widow*, *Hellraiser*, and *Star Trek*.

MARK HARRISON's comic book work has appeared in *2000 AD*, *Glimmer Rats*, and *The Ten Seconders*.

RICH HEDDEN has contributed to the *Star Wars Tales* series as well as to *Star Wars Galaxy Magazine*.

DANNY HELLMAN is an illustrator and cartoonist whose work has appeared in many publications, including *Time*, *Fortune*, *Sports Illustrated*, and the *Wall Street Journal*, as well as in several DC Comics publications.

SHEPHERD HENDRIX has worked as an inker for DC, Dark Horse, Tundra, Kitchen Sink, and Milestone Comics.

DAVE HOOVER started his career as an animator working on *Fat Albert*, *Tarzan*, *Flash Gordon*, and numerous other programs and films before switching to comics in the late 1980s.

JANET JACKSON is the production and design director for Illustrated Media Group LLC and has created many covers for Marvel Comics.

JANINE JOHNSTON's artwork appears in *Star Wars: Tales of the Jedi.*

JEFFREY JONES illustrated numerous comics and created art for more than 150 book covers. He was also known for his work in the fine arts. Frank Frazetta considered Jones our "greatest living painter."

KELLEY JONES is a comic book artist known for his distinctive run on *Batman* with writer Doug Moench, as well as for his work on *The Sandman* with Neil Gaiman.

MICHAEL KALUTA is an award-winning artist who is acclaimed for his adaptation of the pulp magazine hero the Shadow with Dennis O'Neil in the 1970s.

GIL KANE was a veteran comic artist and co-creator of the DC Comics super heroes Green Lantern and the Atom.

CAM KENNEDY's comic book art appeared in *2000 AD* and most notably on *Star Wars: Dark Empire* by Tom Veitch. This six-issue miniseries, first published by Dark Horse in 1991 and 1992, ushered in the modern era of *Star Wars* comics.

DALE KEOWN is a comic book artist best known for his work on *The Incredible Hulk* and his creator-owned series *Pit*.

KARL KESEL has written, inked, and penciled most of the major comic book characters, including Superman, Superboy, Spider-Man, Fantastic Four, and Captain America.

SAM KIETH is the creator of *The Maxx* and *Zero Girl*.

MIRAN KIM's work can be seen on the covers of the *X-Files* and *Mars Attacks* comic book series for Topps.

JACK KIRBY, known as the King of Comics, is widely regarded as the industry's most prolific and influential illustrator, creating and co-creating more than one hundred major characters. For Marvel Comics alone his seminal creations include Captain America, the Fantastic Four, the Silver Surfer, the Mighty Thor, the X-Men, Iron Man, the Incredible Hulk, and the super hero team the Avengers.

RAY LAGO is a comic book artist and cover painter whose work has appeared on several comic books in Dark Horse's *Predator* line.

DAVID LAPHAM is a writer, artist, and cartoonist known for his indie comic book series *Stray Bullets*.

RICH LARSON is an artist and the other half of the Fastner & Larson team.

ZOHAR LAZAR is an illustrator and frequent contributor to the *New Yorker,* the *New York Times Magazine*, *Rolling Stone*, *Esquire*, and *GQ*.

JAE LEE first became known for his work on *Namor the Sub-Mariner*, *Hellshock*, *Our Worlds at War,* and his collaboration with Paul Jenkins on *Inhumans*.

PAUL LEE is a painter and illustrator who has worked on *Batman* and the series *Case Files: Sam & Twitch*.

MIKE LEMOS has worked as an illustrator and graphic designer on toys, trading cards, and character concepts.

JOHN PAUL LEON penciled the Milestone title *Static* and the Marvel Comics series *Earth X*.

VINCE LOCKE is the co-creator, writer, and artist of *Deadworld* and the graphic novel *A History of Violence*, which was adapted for film by director David Cronenberg.

JOHN PAUL LONA produced art for a number of FASA-era BattleTech and MechWarrior titles.

DAVID LOWERY is a storyboard artist who began his career at Industrial Light & Magic. His film credits include *Willow*, *Jurassic Park*, *The Flintstones*, and *The Rocketeer*.

ESTEBAN MAROTO's work includes illustrations for *1984*, *Creepy*, *Eerie*, *Vampirella*, *Amethyst*, *Zatana*, and *Savage Sword of Conan*.

CYNTHIA MARTIN's comic book work includes *Star Wars* for Marvel Comics.

SHAWN C. MARTINBROUGH is a writer and illustrator, cofounder of Verge Entertainment, and artist of the bestselling monthly series *Thief of Thieves*.

MIKE MAYHEW has created covers for Marvel and worked on *Spawn* and *X-Men Origins: Jean Grey*.

MARK "CRASH" MCCREERY is a concept illustrator for the movies, including the *Jurassic Park* film series.

WALTER MCDANIEL is a writer and editor who has contributed to the comic books *Deadpool*, *Wolverine*, *Deathlok*, *Spider-Man*, *Captain America*, *Batman*, and *X-Men*.

MIKE MCMAHON is the comic artist behind well-known characters from *2000 AD*, including Judge Dredd, Sláine, and ABC Warriors.

MIKE MCPHILLIPS is an inker whose work has appeared in *Dark Horse Presents*.

RALPH MCQUARRIE is the most iconic artist in the history of *Star Wars,* working hand in hand with George Lucas to establish the saga's distinctive visual aesthetic. Beyond designing Darth Vader, C-3PO, and R2-D2, McQuarrie

produced hundreds of pieces of artwork, including conceptual paintings, costume designs, storyboards, and matte paintings, as well as posters, book jackets, and album covers.

LINDA MEDLEY is the author and illustrator of the *Castle Waiting* series of comic books and graphic novels.

MICHAEL MIGNOLA is an award-winning comic book artist and writer best known as the creator of *Hellboy*.

DAVID O. MILLER's illustrations appear in the *Dungeons and Dragons* series.

STEVE MITCHELL has worked for DC Comics, Marvel, Dark Horse, and Milestone, inking popular comic book characters such as Batman, Iron Man, and the Predator.

CHRISTOPHER MOELLER is a writer and painter whose signature creation is the *Iron Empires* sci-fi universe.

JEROME MOORE has illustrated various *Star Trek* comics.

C. SCOTT MORSE is an animator, filmmaker, comic book artist, and writer known for his 1997 epic series *Soulwind*, which was nominated for both the Eisner and Ignatz Awards.

JON J MUTH is a former comic book artist whose work includes *M*, *The Mystery Play* with Grant Morrison, *Moonshadow*, *Swamp Thing*, and *The Sandman* with Neil Gaiman. Muth is now a celebrated and award-winning children's book creator whose bestselling picture books include *Zen Shorts* (which was named a Caldecott Honor Book); *Come On, Rain!*; *Stone Soup*; *The Three Questions*; and *A Family of Poems* by Caroline Kennedy.

SCOTT NEELY is an illustrator who has worked with Warner Bros., Cartoon Network, and Disney.

TERESE NEILSEN is a fantasy artist and illustrator who has worked on several trading card series, graphic novels such as *Ruins* for Marvel Comics, and covers for *Xena* and *Star Wars*.

MARK NELSON worked on the *Aliens* series for Dark Horse Comics and many *Dungeons & Dragons* books.

HOANG NGUYEN, a comic book and digital artist who created the miniseries *Carbon Grey*, has worked for Dark Horse and Marvel Comics.

EARL NOREM is known for his painted covers for men's adventure magazines and his work on numerous Marvel Comics projects including *Planet of the Apes* and *Silver Surfer*.

ALLEN NUNIS is a role-playing game artist whose comic books include *Aliens: Colonial Marines* and *Classic Star Wars*.

MITCH O'CONNELL has contributed to *Rolling Stone*, *Playboy*, *Newsweek*, *Time,* the *New Yorker*, and FASA.

MIKE AVON OEMING is a comic book artist and writer who has contributed to *The Mice Templar* and *Powers* series.

KEVIN O'NEILL is the co-creator of *Nemesis the Warlock* with Pat Mills and *The League of Extraordinary Gentlemen* with Alan Moore.

RICHARD ORY has worked on comics for several studios, including Marvel, DC, and Dark Horse Comics.

MARK PACELLA is a writer, artist, and creator of the miniseries *Tooth and Claw*.

JASON PALMER is an artist whose illustration work includes *Battlestar Galactica*, *Indiana Jones*, *Star Trek*, *Harry Potter*, and *Firefly*.

JIMMY PALMIOTTI is a writer and inker and has worked as an editor for Marvel Comics and Kickstart Comics. Some of his titles include *Punisher*, *Ghost Rider*, *Ash*, *Jonah Hex*, and *Harley Quinn* with his wife Amanda Conner.

JASON PEARSON is a comic book writer and artist on *Legion of Super-Heroes* and his own creator-owned series *Body Bags*.

GEORGE PÉREZ is an award-winning artist who has worked on *The Avengers, Teen Titans, Wonder Woman*, and most notably the epic crossover series *Crisis on Infinite Earths* for DC Comics.

BRANDON PETERSON's comic book work includes *Uncanny X-Men* for Marvel Comics and *Codename: Strykeforce* for Top Cow.

JOE PHILLIPS has worked for Marvel, DC, and Dark Horse Comics on characters such as Superboy, Silver Surfer, Wonder Woman, Speed Racer, and Mister Miracle.

WHILCE PORTACIO is a comic book writer and artist known for his work on *The Punisher*, *X-Factor*, *Uncanny X-Men*, *Iron Man*, *Wetworks*, and *Spawn*.

JOHN POUND is the artist behind the *Garbage Pail Kids* stickers for Topps and a regular contributor to *MAD* Magazine.

GEORGE PRATT is an award-winning writer and painter known for his celebrated graphic novels *Enemy Ace: War Idyll* and *Batman: Harvest Breed*.

DON PUNCHATZ was a science fiction and fantasy artist who drew illustrations for *Heavy Metal, National Geographic, Playboy,* and *Time*.

JOE QUESADA is a comic book editor, writer, and artist who has worked on numerous books for DC Comics and Marvel. Quesada was editor in chief of Marvel Comics from 2000 to 2011, serving longer in that position than anyone other than Stan Lee.

TOM RANEY is the illustrator of *Annihilation: Conquest, Ultimate X-Men,* and *Uncanny X-Men* for Marvel and *Outsiders* for DC Comics.

JEFF REBNER is a veteran illustrator who has worked on such projects as *Cybernary, Wetworks,* and *The Incredible Hulk*. He is also known for his work on the TV shows *American Dad!*, *King of the Hill,* and *Extreme Ghostbusters*.

RALPH REESE has illustrated for books, magazines, trading cards, comic books, and comic strips, including a run on the *Flash Gordon* comic strip for King Features. Reese also collaborated with Byron Preiss on the continuing feature *One Year Affair*, which was first serialized in *National Lampoon*.

STEVEN R. REISS is a toy designer and illustrator.

P. CRAIG RUSSELL is a comic book writer, artist, and illustrator whose work has won multiple Harvey and Eisner Awards.

ZINA SAUNDERS, daughter of Norm Saunders, the pulp artist behind *Mars Attacks*, is an artist, writer, and animator who has contributed to the *Wall Street Journal*, the *New York Times Book Review*, and *Time Out New York*.

CLARK SCHAFFER is a Hollywood special-effects designer who has worked on *Iron Man 2*, *Speed*, and *Batman Forever*.

MARK SCHULTZ is the writer, illustrator, and creator of *Xenozoic Tales*, later known as *Cadillacs and Dinosaurs*.

BILL SIENKIEWICZ is an award-winning artist and writer of hundreds of comics for DC Comics and Marvel, including *The New Mutants* and *Elektra: Assassin*.

WALTER SIMONSON is a legendary comic book writer and artist whose celebrated run on *Thor* was one of the sources for the blockbuster film series. Simonson was also the illustrator of *X-Factor* and *Fantastic Four* for Marvel; *Detective Comics*, *Manhunter*, *Metal Men*, and *Orion* for DC Comics; and licensed properties such as *Star Wars*, *Alien*, *Battlestar Galactica*, and *Robocop vs. Terminator*.

JOSEPH SMITH created iconic portraits and movie posters for Hollywood, most notably the Academy Award–winning film *Ben-Hur*, as well as *Doctor Dolittle*, *Mutiny on the Bounty*, and *Earthquake*.

MIKE SMITHSON is a film artist who designed and rendered original creature concepts for Stan Winston's digital effects studio. Smithson has worked on *Star Trek: The Next Generation*, *Tank Girl*, *Austin Powers: The Spy Who Shagged Me*, and *Avatar*.

JOHN K. SNYDER III is a writer and comic book illustrator whose work includes *Suicide Squad*, *Doctor Mid-Nite*, and *Grendel*.

CHRIS SPROUSE is a two-time Eisner Award–winning comic book artist who illustrated the DC comic *Tom Strong*, written by Alan Moore.

JIM STARLIN is a veteran comic book writer and artist who revamped the Marvel Comics characters Captain Marvel and Adam Warlock, and created/co-created the Marvel characters Thanos; Drax the Destroyer; Gamora; and Shang-Chi, Master of Kung Fu.

KEN STEACY is a comics artist and writer whose work includes *Astro Boy* and *Jonny Quest*.

BRIAN STELFREEZE is a painter, penciller, inker, and colorist who has worked for nearly every major American comic book publisher. Most notable are his fifty-plus Batman cover illustrations for *Shadow of the Bat* for DC Comics.

DAVE STEVENS was an award-winning illustrator and the creator of *The Rocketeer*, which was adapted as a feature film in 1991.

WILLIAM STOUT is an award-winning artist and writer who has worked for more than forty-five years in various media, including comics (*Tarzan* and *Little Annie Fanny*); film (with Monty Python, Jim Henson, Steven Spielberg, Guillermo del Toro, and Disney); the record industry; magazine illustration; and public murals at museums across the country, including the San Diego Natural History Museum and the Houston Museum of Natural Science. He is the author and illustrator of *Legends of the Blues*.

DREW STRUZAN's award-winning art is some of the most iconic in modern cinema. He has more than 150 movie posters to his credit, including every *Star Wars* and *Indiana Jones* film, as well as the *Back to the Future* trilogy, *Blade Runner*, *E.T. the Extra-Terrestrial*, *The Muppet Movie*, and *Harry Potter and the Sorcerer's Stone*.

ARTHUR SUYDAM is a comic book artist and writer who has worked on the *Batman*, *Conan*, *Tarzan*, *Predator*, *Aliens, Death Dealer*, and the *Marvel Zombies* series.

SYLVAIN is a director and screenwriter with a background in illustration. He was mentored by Jean "Moebius" Giraud.

TOM TAGGART uses three-dimensional sculptures for his cover art is the artist on *Predator: Nemesis* for Dark Horse Comics.

GREG THEAKSTON is an historian and illustrator whose "Theakstonizing" process is used in comics restoration.

ART THIBIRT is a comic book inker for Marvel Comics whose work includes *X-Men* in the 1990s.

MICHAEL THIBODEAUX is a graphic artist and art director who has worked for Mattel, Disney, and Warner Bros. For more than fourteen years Thibodeaux collaborated with Jack Kirby on a variety of projects, including presentations for animation.

CATHLEEN THOLE is an illustrator and graphic designer who has worked for Marvel and DC Comics.

JILL THOMPSON is a comic book writer and illustrator known for her work on Neil Gaiman's *The Sandman* and her own *Scary Godmother* series.

ANGELO TORRES is a veteran comic book artist who has worked for E. C. Comics, Atlas, Warren Publishing, and *MAD* Magazine, and was named one of the Top 100 Artists of American Comic Books by direct market retailers .

TIM TRUMAN is the writer and artist of *Grimjack* with John Ostrander, *Scout*, and Jonah Hex with Joe R. Lansdale.

KEITH TUCKER is a comic artist and animator who has worked for Disney, Marvel, and Warner Bros.

JIM VALENTINO is a writer, penciller, editor, and publisher of comic books including *Guardians of the Galaxy*.

BORIS VALLEJO's award-winning fantasy art is known and loved around the world, most notably for his illustrations of Tarzan, Conan the Barbarian, and Doc Savage. He has also done illustration work for movie posters, advertising, collectibles, trading cards, and sculpture.

JOHN VAN FLEET works mostly as a cover artist but has also created interiors for comics such as *Batman: The Chalice* and *Batman/Poison Ivy: Cast Shadows.*

CHARLES VESS is an award-winning fantasy artist and comic book illustrator who specializes in the illustration of myths and fairy tales. He is best known for his illustrations in *Stardust* and *Sandman* by Neil Gaiman.

RUSSELL WALKS is the cover artist for *Star Wars: Tales of the Jedi*, *Angel*, and *Indiana Jones.* He has worked for DC Comics, Dark Horse, Marvel Comics, and IDW Publishing.

JEFF WATTS is an artist and owner of Watts Atelier of the Arts.

AL WILLIAMSON was a veteran comic book artist who specialized in adventure, Western, and sci-fi/fantasy. He is best known for his work on the *Flash Gordon*, *Star Wars* comic books, and the *Star Wars* newspaper strip.

GAHAN WILSON is among the most popular and beloved cartoonists in the history of the medium, whose career spans the second half of the twentieth century and all of the twenty-first. His work has appeared in the pages of *Playboy*, the *New Yorker*, *Punch*, and the *National Lampoon*.

THOMAS WM. YEATES II is a comic book and comic strip artist whose work includes *Sgt. Rock*, *Prince Valiant*, and *Zorro*.

MIKE ZECK has worked for Charlton, DC Comics, Marvel, and Image, illustrating *Master of Kung Fu*, *The Amazing Spider-Man*, *Action Comics*, *Batman: Legends of the Dark Knight*, and *Captain America.*

BRUCE ZICK is an illustrator and production designer for numerous films, magazines, animation, and television projects. He has worked on such movies as *WALL-E*, *Finding Nemo*, *Tarzan*, and *The Lion King.*

ARTIST INDEX

4-01-2

win!

STAR WARS

Send a postcard with your name, birthdate, complete mailing address and we'll enter you to win the following: a complete set of 140 STAR WARS GALAXY trading cards; a complete set in uncut sheet format; plus an uncut sheet of etched foil chase cards. 200 winners will be randomly selected and notified by mail. Enter as often as you like.

0 41116 00403 2

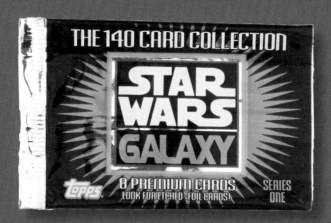

THE 140 CARD COLLECTION

STAR WARS GALAXY

8 PREMIUM CARDS
LOOK FOR ETCHED-FOIL CARDS!

topps.

SERIES ONE

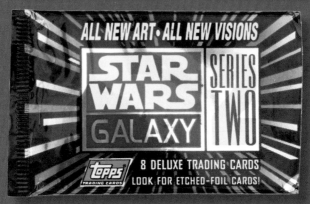

ALL NEW ART · ALL NEW VISIONS

STAR WARS GALAXY

SERIES TWO

topps
TRADING CARDS

8 DELUXE TRADING CARDS
LOOK FOR ETCHED-FOIL CARDS!

topps
TRADING CARDS

7 DELUXE TRADING CARDS

STAR WARS GALAXY

LOOK FOR
CLEARZONE™ CARDS
ETCHED-FOIL CARDS
LUCAS ARTS CARDS
RANDOMLY DISTRIBUTED